IMAGES
of America

ATLANTA'S PARKS AND MONUMENTS

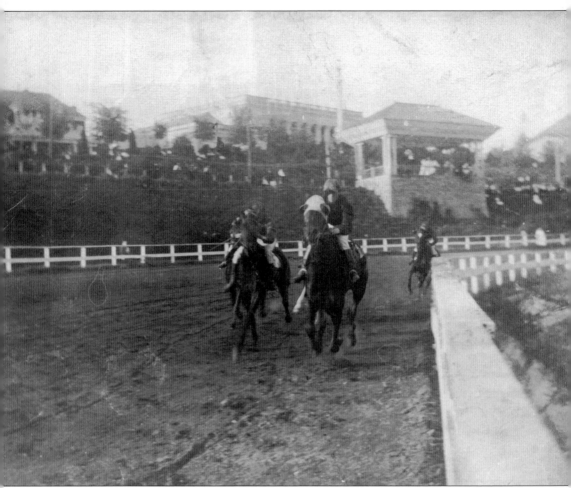

The founding of Piedmont Park near downtown began after 1887 when the Gentlemen's Driving Club, later the Piedmont Driving Club, bought land from Benjamin Walker for recreation and the driving or racing of horses. The Piedmont Exposition Company made an agreement with the driving club so that it could hold expositions and fairs on club land. The City of Atlanta purchased it from the club and expanded it in 1904, forming Piedmont Park, Atlanta's most central park. (Courtesy Atlanta History Center.)

ON THE COVER: To the right, slightly out the picture, is the 65,000-square-foot US Government Building that was one of the major exhibition halls built for the 1895 Cotton States and International Exposition. The building to the left is the Fine Arts Building. The great staircases remain in what has now become Piedmont Park, with the exception of the ceremonial columns that flanked them. Other major buildings constructed for the exposition included the Georgia, Electrical, Machinery, Negro, and Women's Buildings. These housed over 6,000 exhibits during an exposition that occupied the Grand Ellipse, now called the Active Oval. (Courtesy Atlanta History Center.)

IMAGES
of America

ATLANTA'S PARKS AND MONUMENTS

Rodney Mims Cook Jr.

ARCADIA
PUBLISHING

Published by Arcadia Publishing
Charleston, South Carolina

Printed in the United States of America

Library of Congress Control Number: 2012956069

For all general information, please contact Arcadia Publishing:
Telephone 843-853-2070
Fax 843-853-0044
E-mail sales@arcadiapublishing.com
For customer service and orders:
Toll-Free 1-888-313-2665

Visit us on the Internet at www.arcadiapublishing.com

*To Bess Mims Cook, Rodney Mims Cook, and Bettijo
Trawick, who taught me the value of looking back for
inspiration to improve the human condition going forward*

CONTENTS

ACKNOWLEDGMENTS

My grandmother and my parents carted me to old places. The East Coast of the United States, particularly the Southern coast, was their favorite. At the age of four, I was wandering with my grandmother through the ruins of Dungeness on Cumberland and the Jekyll Island Club when it was abandoned. The Spanish moss of the Georgia live oaks and the views across miles of Georgia marsh to the mainland were so beautiful that any child would have difficulty not liking it.

My thanks to them and my sister, Jody Cook. She has a postcard collection that I heavily borrowed from. Our friend Kenneth H. Thomas Jr. also has one, and he was equally helpful. My darling wife, Emily, contributed her photographs and was understanding of my getting home so late in the last few months. Ken Insley and Scott Robertson have done beautiful photography for me before at the Millennium Gate Museum and have done so again in this book. Caskey Cunningham is a very talented photographer, and she was understanding of the unusual places I made her go to get the right picture. Cunningham is a credit to her alma mater, the Savannah College of Art and Design (SCAD). I would like to thank Gwen Spratt and Ellen Johnston at Georgia State University Special Collections and Archives (GSU) for their help to find some of the more obscure images of our history. A thanks also goes to Ashley Szczepanski of the Piedmont Park Conservancy, who helped with their superb archive. Sheffield Hale, our new president of the Atlanta History Center (AHC), who always helps with the strangest of requests, did so again. He led me to curator Paige Adair, whose collection is shared in these pages. Thanks to Dr. Catherine Lewis, whose assemblage of the history collection at the Millennium Gate Museum allowed me to know what Hale and Adair had on Andrews Drive. I would like to thank National Monuments Foundation (NMF) scholars Tan Siu and Paige Purington, who were my initial collaborators. Ross Faulds, another SCAD student and NMF scholar, took the book to the next step. Finally, thank you to Mac Schmitz, who is hopefully sleeping right now after numerous 3:00 a.m. workdays, for taking Faulds's work and refining it.

INTRODUCTION

Humans have always aspired to build great things that commemorate great people or events. This book will give you a glimpse into how the citizens of the capital of Georgia chose to build, and continue to build, grand monuments to great events and people and the beautiful parks in which to enjoy many of them. This region of the world has been populated by humans for thousands of years. Numerous glyph carvings and rock mounds (including the one below, Rock Eagle, a giant eagle over 120 feet wide located near Eatonton) situated east of Atlanta survive to this day. The Ocmulgee mound at what is now Macon, Georgia, is the largest in the state and one of its oldest monuments still in existence.

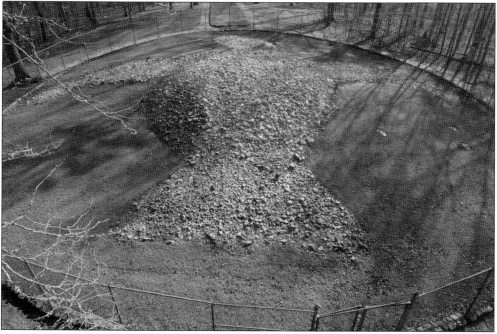

(*Courtesy NMF.*)

The first monumental building in Atlanta was the fort at Standing Peachtree. Lt. George Gilmer, later a governor of Georgia, completed it at the confluence of Nancy Creek and the Chattahoochee River in 1814 near a Creek Indian settlement. Such forts were created for the protection of the area's new settlers due to British agitation of the natives during the War of 1812. The worst Indian massacre of settlers occurred at Fort Mims, near what is today's Columbus, Georgia. British agitation also was occurring on the New York–Canadian border. Confiscation of American sailors and ships were also a cause of this war.

A major facilitator in the growth of Atlanta during the mid-19th century was the railroad terminus. Zero Mile Post is a stone marker in Underground Atlanta that marks the wilderness site where the railroad was to cross before approaching the nearby mountains. A Georgia historical marker helped visitors find Zero Mile Post for over a century, as the streets of downtown were raised over the railroad, and it was dark and unusual down there until Underground Atlanta was developed in the 1960s. It is now contained within a building and is the first monument in the city of Atlanta.

The growth of Atlanta was halted when the American Civil War left the state of Georgia in ruins. Atlanta monuments would never be so humble again. "Never before or since . . . has there been a period when the general level of excellence was so high in American architecture, when the ideal was so constant, and its varying expressions so harmonious, when the towns and villages, large and small, had in them so much unostentatious beauty and loveliness as during the forty years from 1820 to the Civil War," said architecture historian Talbot Faulkner Hamlin.

(Courtesy Emily Robinson Cook.)

The destruction of the city resulted in the disappearance of most of the monuments and buildings. The Gilded Age and the 1895 Cotton States and International Exposition, where the world's cultural, agricultural and manufacturing products were exhibited while promoting civil liberties for women and African Americans, returned a grand tradition of beauty in monuments and architectural style that is still the Atlanta standard over a century later. The Federal era of the early 19th century gave way to the more elaborate Victorian era, and the classical standard throughout Georgia and the South adjusted to this new Gilded Age. The monuments and great buildings were reconstructed, as the city was determined that it would not be defeated. These structures have never been catalogued before.

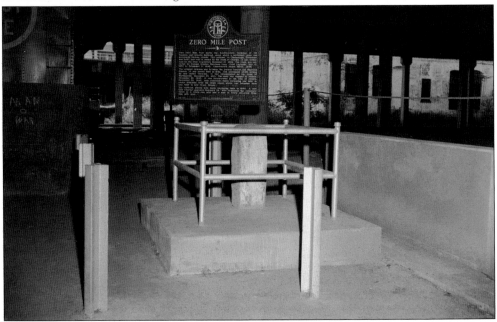

(Courtesy Atlanta History Center.)

8

One

CIVIC PARKS

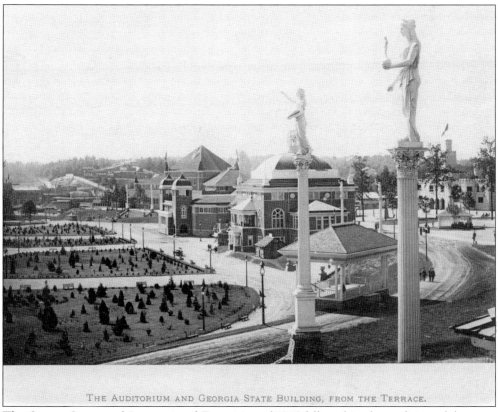

THE AUDITORIUM AND GEORGIA STATE BUILDING, FROM THE TERRACE.

The Cotton States and International Exposition of 1895 followed in the tradition of the great world's fairs in Philadelphia, London, Chicago, Paris, and other great cities. The Grand Ellipse spreads south from the Terrace; behind the Terrace today is the site of the Fuqua Conservatory of the Atlanta Botanical Garden. The domed Georgia Pavilion on the right is the scene of the famous "Atlanta Compromise" speech by Booker T. Washington. The former driving track and racetrack of the Piedmont Driving Club circumvents the ellipse. Statuary abounded the tops of Corinthian columns all over the fair. (Courtesy Atlanta History Center.)

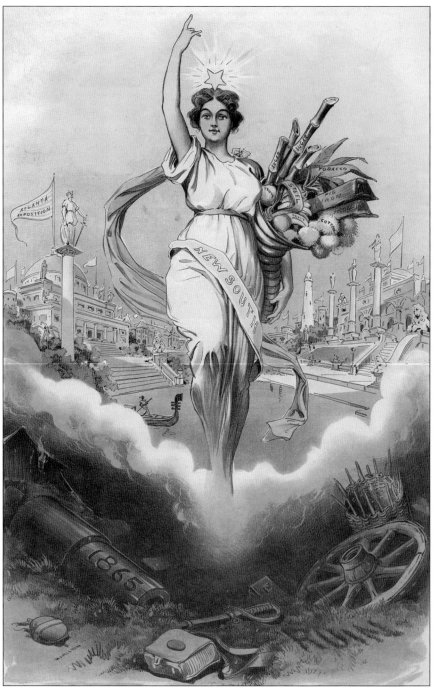

In 1895, Atlanta was a tiny town, yet its citizens have always aspired for greatness and were not going to let the burning of the city by Gen. William Sherman deter them. Approximately one million visitors attended the fair, and it was opened by the president of the United States at the time, Grover Cleveland. The impact on the city was as great as the Olympic Games held over a century later in 1996. This image shows the vibrant allegorical "New South," open for business again atop the ruins of the Civil War. (Courtesy Atlanta History Center.)

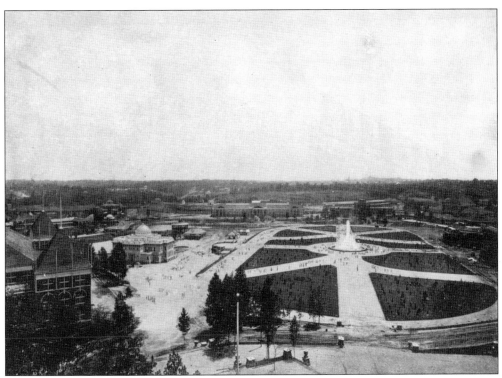

The Grand Ellipse was the most popular place to gather and promenade at the fair. It was surrounded by monumental buildings, lakes, and statuary. The grounds by the Olmsted Brothers are today among the most beautiful in the city. Sadly, the monumental fountain in the center of the active oval no longer exists. (Above, courtesy AHC; below, courtesy Ken Insley.)

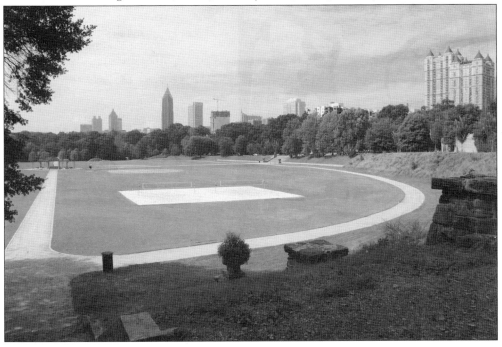

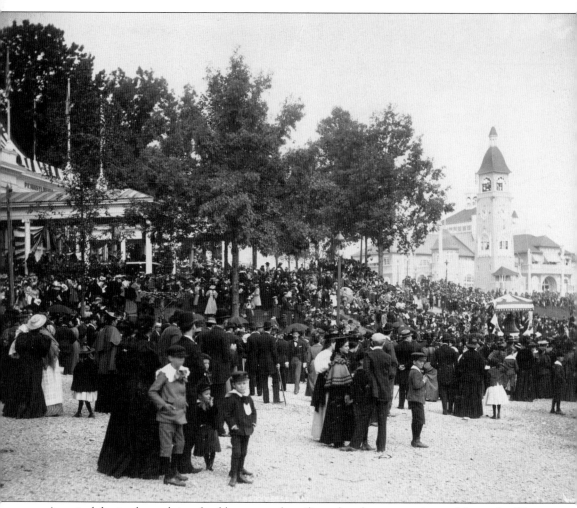

A typical day in the park involved large crowds, military bands, ceremonies, and fireworks. This was one of the first events in American history to have electric lights. (Courtesy AHC.)

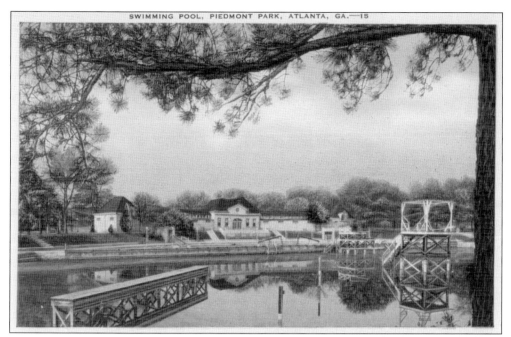

The historic bathhouse, located in Piedmont Park on Lake Clara Meer, was first built in 1911 and constructed of wood. Renovations to Piedmont Park led to the reconstruction of the bathhouse in 1926, which was built in stone. The lake became a place for swimming with diving platforms, sunning platforms, and a waterslide. (Courtesy Kenneth H. Thomas Jr.)

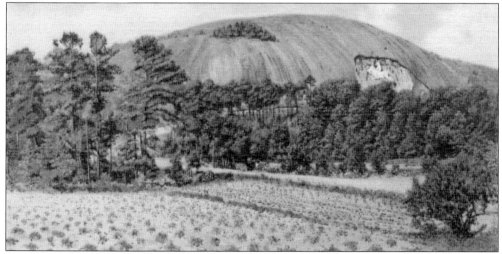

Stone Mountain Park is a popular recreational park, and at a height of 825 feet it is the largest granite outcropping in the world. Depicted on the side of Stone Mountain is a memorial carving of three Civil War leaders on horseback: Pres. Jefferson Davis, Gen. Robert E. Lee, and Gen. Thomas "Stonewall" Jackson. The carved depiction of the men spans the length of a football field and is the largest bas-relief in the world. The Stone Mountain Monumental Association hired Gutzon Borglum, who later created the Mount Rushmore Memorial, to begin the Stone Mountain project in 1915; however, after altercations between Borglum and the association, he was fired after completing partial work in 1924. Chief carver Roy Faulkner and several workmen completed the carving in 1972. A dedication ceremony took place on May 9, 1970. (Courtesy J. Cook.)

The Grant Park entrance at the lake and zoo has a very rustic bucolic appeal to it. Lemuel P. Grant donated land to the city in 1881, creating the oldest surviving park in Atlanta. It is also the home of the Cyclorama Museum. The major battle of the Siege of Atlanta occurred on what became parkland and the immediate surrounding area. (Courtesy Kenneth Thomas Jr.)

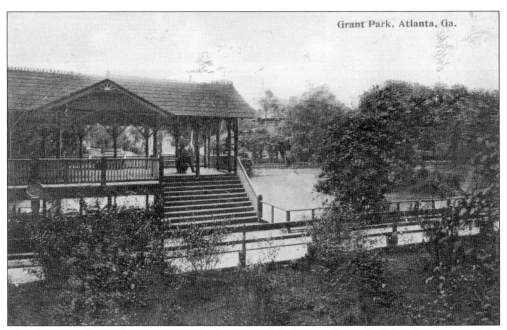

Grant Park, Atlanta, Ga.

The Grant Park Boathouse is named after Lemuel P. Grant. Grant Park has been one of the most beloved parks in the Atlanta parks system for many generations. (Courtesy Kenneth H. Thomas Jr.)

14

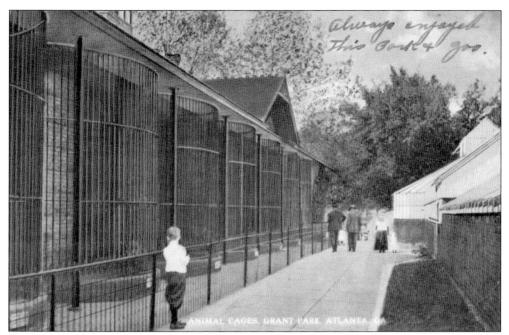

always enjoyed this park & zoo.

ANIMAL CAGES, GRANT PARK, ATLANTA, GA.

Zoo Atlanta's early beginnings included gifts of numerous animals from the private zoo of Coca-Cola magnate Asa G. Candler Jr. His estate, Briarcliff Manor, was walled and contained a zoo for a number of years. His two elephants—Coca and Cola—were a part of this gift. Willy B., the gorilla, a later addition, was named after Mayor William B. Hartsfield. (Courtesy Kenneth H. Thomas Jr.)

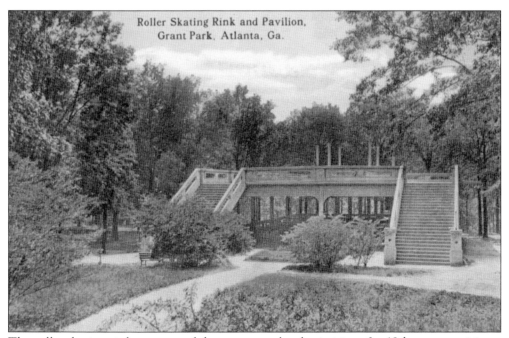

Roller Skating Rink and Pavilion, Grant Park, Atlanta, Ga.

The roller-skating rink was one of the most popular destinations for 19th-century visitors. Both levels could be used, and the structure stood until the end of the 20th century. (Courtesy Kenneth H. Thomas Jr.)

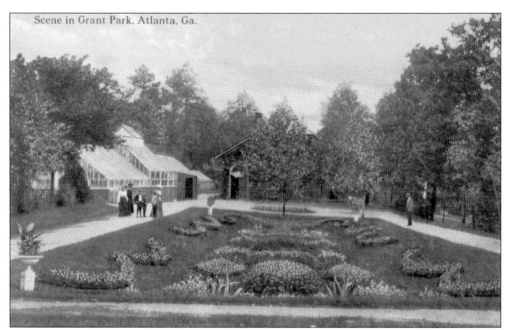

The sunken garden at Grant Park provided an elegant promenade for the ladies of the city. Weekends offered frequent opportunities for strolling and parading the latest fashions of the Victorian era. (Courtesy Kenneth H. Thomas Jr.)

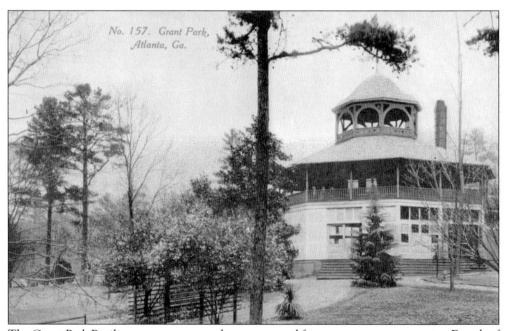

The Grant Park Pavilion was an octagonal structure used for numerous events, parties, Fourth of July celebrations, and political rallies. It was on a promontory overlooking the Grant Park lake. (Courtesy Kenneth H. Thomas Jr.)

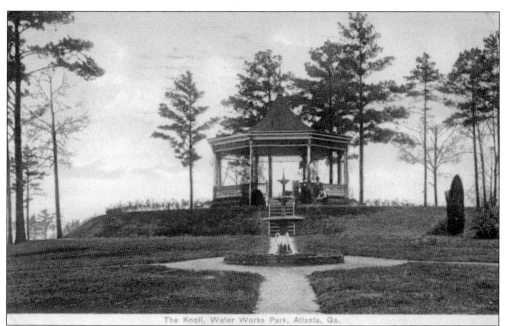

The Knoll, Water Works Park, Atlanta, Ga.

The 19th-century Howell Mill gazebo was on a promontory overlooking the Atlanta reservoirs and the city skyline in the distance. It was one of the most beautiful places in town for gatherings large and small. The bronze-domed gazebo at Woodruff Park is in the heart of Five Points downtown and has a monumental chess set underneath it, which is in constant use. (Above, courtesy Kenneth H. Thomas Jr.; at right, Ken Insley.)

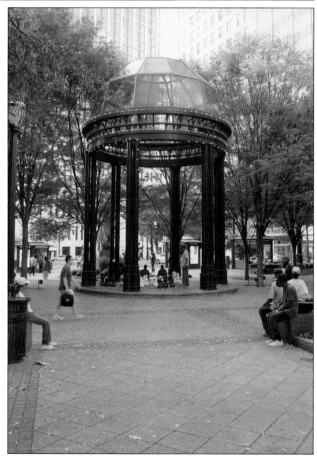

Joel Hurt had landscape architect Frederick Law Olmsted design the master plan, implemented by Olmsted Brothers, for the Linear Park in the Druid Hills neighborhood. The preliminary plan was submitted in 1893 and included Olmsted's design of six segments; the park was completed in 1908 by Asa Candler and Forrest & George Adair. In 1995, the Olmsted Linear Park Alliance completed a master plan for the park's rehabilitation and maintenance. The alliance hired Atlanta landscape architect Spencer Tunnell to implement the rehabilitation. (Courtesy Caskey Cunningham.)

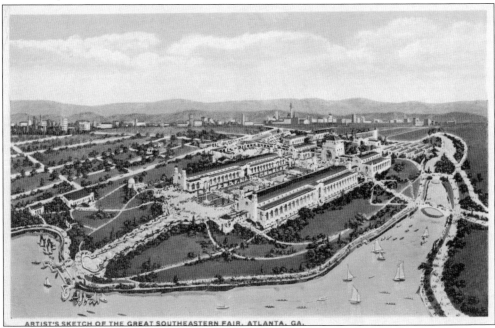

ARTIST'S SKETCH OF THE GREAT SOUTHEASTERN FAIR, ATLANTA, GA.

Lakewood Park, opened in 1893, was on land previously owned by Muscogee Indians. The Southeastern Fair came to the park in 1915, and the Lakewood Speedway was built on the property in 1938. The 1980s brought a motion-picture complex, antique mall, and amphitheater to the grounds after the Southeastern Fair and the Lakewood Speedway were discontinued. (Courtesy Kenneth H. Thomas Jr.)

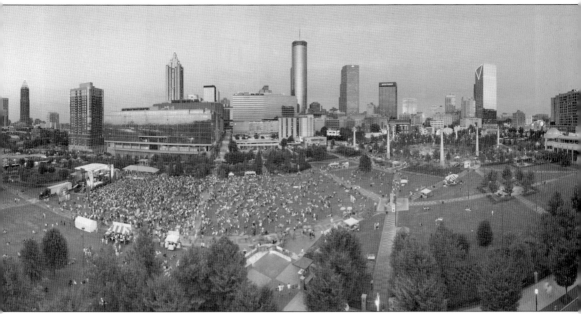

Centennial Olympic Park was developed from a downtown warehouse district for the 1996 Centennial Olympic Games. The 21-acre park is a beautiful addition that provides family activities and live musical entertainment throughout the year. Olympic organizer Billy Payne was primarily responsible for the creation of this park. It was becoming evident that the city should have something permanent as a result of the Olympics, and this was one of the greatest achievements of the Atlanta Organizing Committee. (Courtesy Scott L. Robertson.)

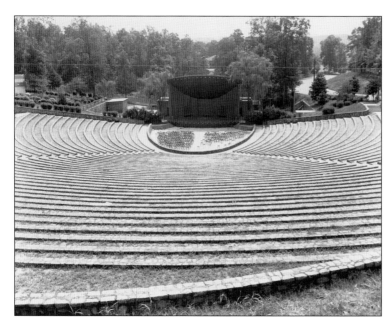

Chastain Park Amphitheater is one of the more enjoyable concert venues in the South. The band shell has evolved since this very early image and takes on more of the look of the Hollywood Bowl. Concertgoers enjoy bringing elaborate picnics with silver candelabra and great food and wine. (Courtesy Georgia State University Special Collections and Archives.)

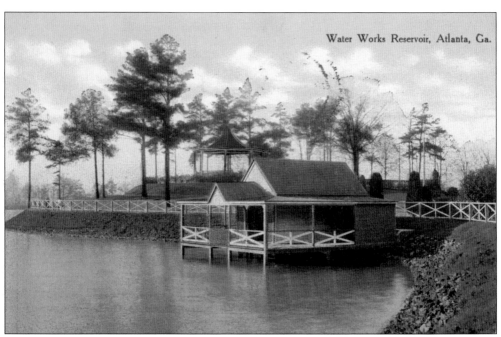

The Water Works Reservoir, constructed in 1892–1893, was located at Howell Mill. It was the second waterworks complex created when city directors realized that a new waterworks system was needed for the growing city. It was designed by engineers Robert M. Clayton and William G. Richards. The boathouse is seen here. (Courtesy Kenneth H. Thomas Jr.)

Two

CIVIC SQUARES

Margaret Mitchell Square, located at the convergence of Peachtree, Ellis, Houston, and Forsyth Streets, was filled with advertisements, billboards, theaters, shops, and the Candler and Rhodes-Haverty Buildings, which were the tallest in the South at the time they were constructed. The square is named after the Pulitzer Prize–winning author of *Gone with the Wind*, Margaret Mitchell, and the film based on her book premiered here at the Loews Grand Theater in 1939. Also on the square is a sculpture and waterfall by Maya Lin, the designer of the Vietnam Memorial in Washington. (Courtesy AHC.)

The typical nighttime experience in Margaret Mitchell Square is shown at left. In contrast, the premiere of *Gone with the Wind* got a bit out of hand relative to how this city usually experienced the theater district. Seen below, the square is a sea of people and searchlights as the great Pulitzer Prize–winner Mitchell and movie stars Clark Gable, Vivien Leigh (with her husband Laurence Olivier), Olivia de Havilland, and Leslie Howard, among many others, joined Mayor Hartsfield, Jock Whitney, David Selznick, Victor Fleming, and the Atlanta elite for the premiere. Hattie McDaniel won an Academy Award for her portrayal of Mammy and became the first African American woman to be honored by the organization; however, due to the laws at the time, she was not permitted to attend the premiere. (Both courtesy AHC.)

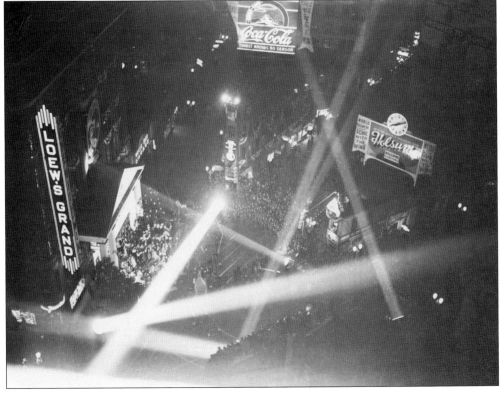

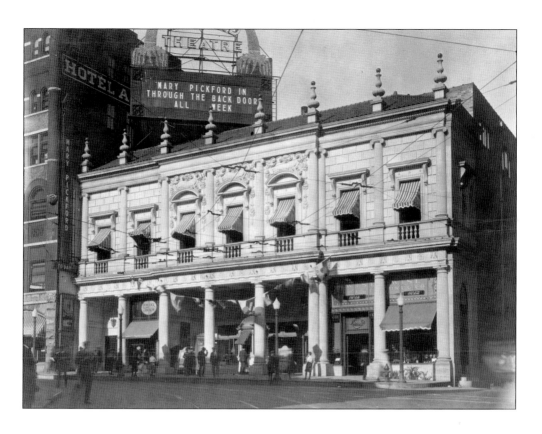

The Howard Theater, designed by Philip Shutze, was based on the Palazzo Chiericati in Vicenza, Italy. The theater was demolished, but the central bays were preserved and made into a residential villa in south Georgia. (Both courtesy AHC.)

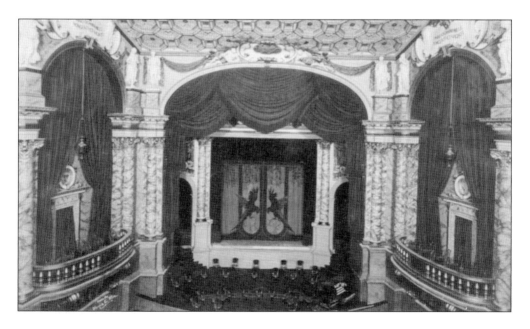

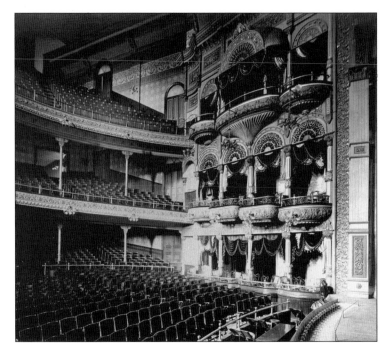

The theater district at Margaret Mitchell Square featured great entertainment for the Atlanta public. The Loew's Grand Theater, pictured here, was the setting for the premiere of *Gone with the Wind*. All of the major Hollywood stars (save one) attended the premiere in Atlanta to celebrate Margaret Mitchell and her great literary achievement. (Courtesy AHC.)

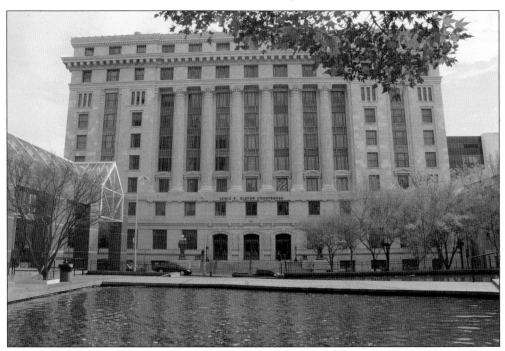

Architect A. Ten Eyck Brown designed the Fulton County Courthouse in 1914, officially known as the Lewis B. Slaton Courthouse. It was listed in the National Register of Historic Places on September 18, 1980. (Courtesy NMF.)

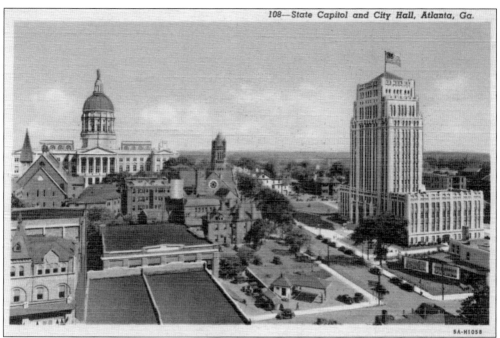

Government Square was originally full of churches and low-rise office buildings. The State of Georgia has removed most of these structures to create a large civic square. The state capitol sits on the highest hill downtown and was originally the site of the Atlanta City Hall–Fulton County Courthouse. The land was donated by Atlanta's sixth mayor, John Mims. When the capital was moved from Milledgeville to Atlanta, the hill site became the preferred choice for the new capitol building, which stands today next to the Gothic city hall and across from the Neoclassical Fulton County Courthouse. (Above, courtesy J. Cook; below, Caskey Cunningham.)

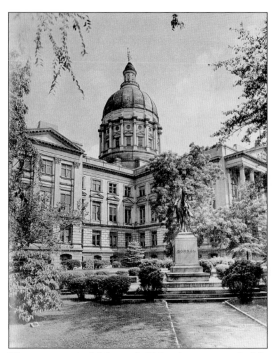

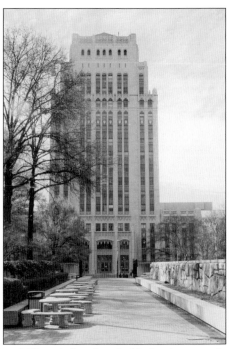

The state capitol (above, left) has been named a National Historic Landmark. Under the rotunda are portraits and statues of Georgia's signers of the Declaration of Independence. Also in the National Register of Historic Places, the city hall building (above, right) is Atlanta's fourth city hall. (At left, courtesy Georgia State University; at right, NMF.)

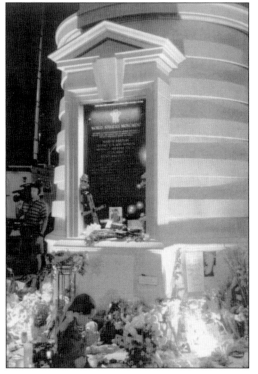

The World Athletes Monument, more commonly known as the Prince Charles Monument, was built at Pershing Point's center to commemorate the Olympic Games. After the death of the Princess of Wales, the square was overwhelmed by tens of thousands of mourners. *The New Yorker* magazine proclaimed the monument to have had the greatest impact of any monument on the city in a century. The city council renamed the intersection after Princess Diana within weeks. (Courtesy Emily Robinson Cook.)

Princess Diana Plaza at Pershing Point is at the northern intersection of Peachtree and West Peachtree Streets. It forms a ceremonial entrance into the city's cultural district. (Courtesy Tan Siu.)

Five Points Plaza was created by the Woodruff Foundation as a large pedestrian passageway square connecting Woodruff Park to Underground Atlanta. It is a brilliant work of urban planning. (Courtesy Caskey Cunningham.)

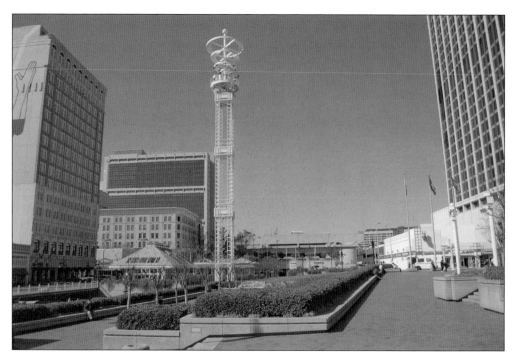

Underground Atlanta Square at the Five Points MARTA station is a significant space with a commanding view of the gold dome of the Georgia State Capitol to the east. A large tower heralds the grand staircase that leads to Underground Atlanta. The tower also plays a role in the Peach Drop on New Year's Eve for the enjoyment of tens of thousands of visitors on the square. (Both courtesy Caskey Cunningham.)

Suntrust Plaza and Hardy Ivy Park are at the southern intersection of Peachtree and West Peachtree Streets in downtown. Together, they form a distinctive square home to an important remnant of the former Carnegie Library in the form of a triumphal arch reconstructed for the Olympic Games designed by Henri Jova for philanthropist Charles Loudermilk. (Courtesy Caskey Cunningham.)

John Portman's important *Ballet Olympia* sculpture, adapted from a Paul Manship creation, is also on the square. Peachtree Street bisects this space and is lined with trees. Unfortunately, in this case, less is more. If the trees formed a perimeter around the square, rather than bisect it, this would have allowed unobstructed views of the monuments and sculpture and be a more successful space. (Courtesy Caskey Cunningham.)

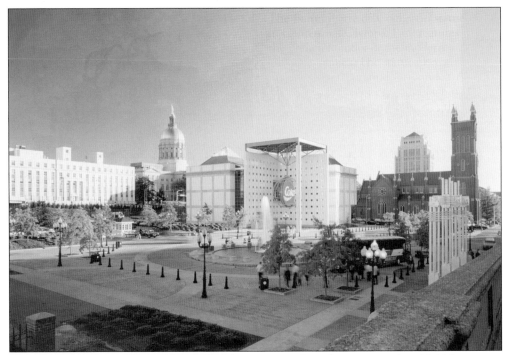

The plaza at the original World of Coke Museum provides a forecourt to the old 19th-century train depot, which is a major events destination. As well, the eastern entrance into Underground Atlanta is served by this plaza. (Courtesy NMF/Coca-Cola.)

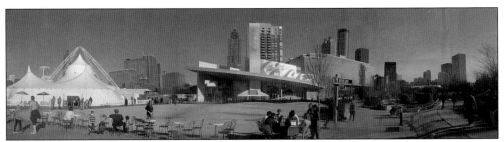

The plaza at the current World of Coke Museum is north of Centennial Olympic Park. It provides the city one of the most beautiful and restful spots to recover from a long day's worth of events at the museum as well as the adjacent Georgia Aquarium, Children's Museum, CNN Center tours, and the numerous other sports arena and museum facilities around this district. (Courtesy of PBandJAdventures.com.)

Three

CIVIC AND GOVERNMENT MONUMENTS

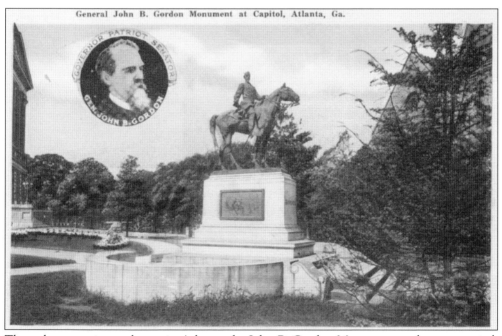

General John B. Gordon Monument at Capitol, Atlanta, Ga.

The only equestrian sculpture in Atlanta, the John B. Gordon Monument at the state capitol, commemorates one of three Georgia soldiers to be ranked as a lieutenant general in the Confederate army. Gordon also served as governor and US senator. Solon H. Borglum designed the bronze statue, which was unveiled on May 25, 1907. (Courtesy J. Cook.)

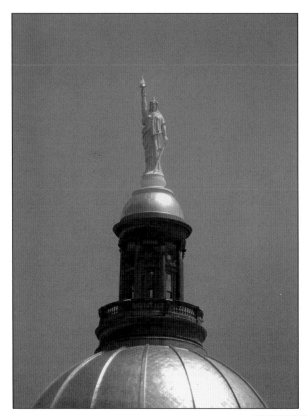

The 26-foot *Freedom* has topped the gold dome of the Georgia State Capitol since 1889. It is copper, painted white, and weighs over 1,600 pounds. The origins of this statue are unknown. Scholars think it was made for Ohio's state capitol but abandoned due to financial issues and gifted to Georgia because of the destruction caused by Ohio-native General Sherman during the Civil War. (Courtesy Max Schmitz.)

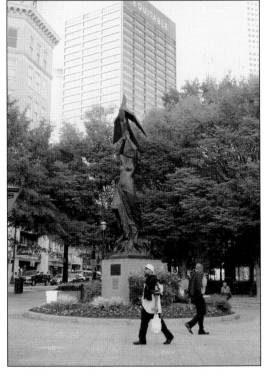

The bronze *Phoenix* is located in Woodruff Park at Five Points in the downtown area. Also known as *Atlanta from the Ashes*, symbolizing Atlanta's rise from the destruction of General Sherman's burning of the city during the Civil War, the monument was designed by James Siegler and sculpted by Frances Somaini. Gifted by the Rich Foundation to the city in 1981, it commemorates the 100th anniversary of Rich's department store. (Courtesy Ken Insley.)

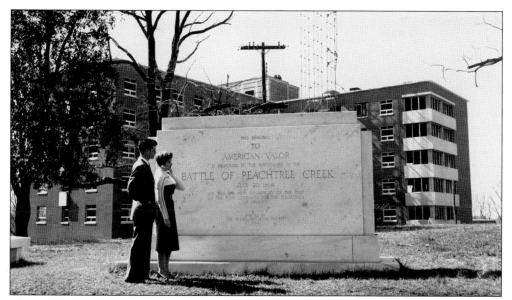

The Battle of Peachtree Creek occurred on July 20, 1864, when Confederate general John Bell Hood defended Atlanta against Gen. William T. Sherman's troops. The battle involved the Army of the Cumberland, commanded by Gen. Henry Thomas, and the Confederate Army of the Tennessee, commanded by Gen. John Hood. This was the first major attack by General Sherman's Union army on Atlanta. Union troops were victorious, and the Confederate armies sustained many casualties. This cenotaph was placed on the highest point of the battlefield and is dedicated to American valor. (Courtesy Georgia State University.)

The Benjamin H. Hill statue, which memorializes the Georgia attorney and public servant who was elected to the Georgia House of Representatives in 1851 and to the Georgia State Senate in 1859, once stood at the southern intersection of Peachtree and West Peachtree Streets. Hill was also a member of the Confederate Provisional Congress and the Confederate States Senate. He served in US House of Representatives from Georgia's 9th Congressional District from 1875 to 1877 and was elected to represent Georgia in the US Senate from 1877 to 1882. The statue has been moved to the north lobby of the state capitol. (Courtesy AHC.)

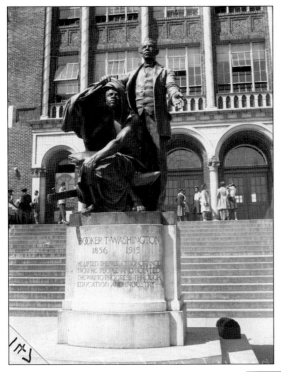

The Booker T. Washington statue, by sculptor Charles Keck, is a copy of the Tuskegee University monument and was placed in front of Washington High School in 1927. Famous for his Atlanta Compromise address given at the 1895 Cotton States and International Exposition, Washington had great influence in the black community and acted as a national spokesman for African American rights. (Courtesy GSU.)

The *Flair Across America* sculpture can be found at the Georgia Dome and the Georgia World Congress Center in the Georgia International Plaza. It is a bronze statue by sculptor Richard MacDonald commemorating the 1996 Atlanta Olympics. It was dedicated on July 8, 1996, and gifted to the City of Atlanta by the sculptor. (Courtesy Caskey Cunningham.)

This monumental work by Alexander Calder sits on the lawn of the High Museum of Art and has become symbolic of the museum itself. Calder's mobiles have been described by Jean-Paul Sartre as "a piece of poetry that dances with the joy of life." As the leading art museum in the southeastern United States, the High Museum of Art, located in Midtown, attracts millions of visitors interested in viewing the 12,000 works of art permanently exhibited at the museum. It houses 19th- and 20th-century American art, European painting and decorative art, African American art, African art, American Southern art, modern and contemporary art, and photography. (Courtesy Caskey Cunningham.)

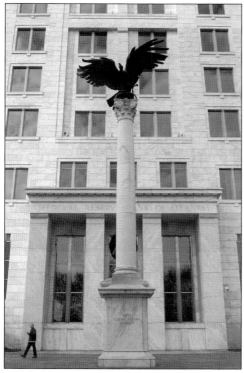

Formerly located on Marietta Street in downtown Atlanta, the Federal Reserve Bank of Atlanta moved to its current location in Midtown in 2001. Crowning one of the plaza's rostral columns is a 3,300-pound cast-bronze sculpture of an eagle. The eagle, made for the bank's original building, was completed in Rome, Italy, by American sculptor Elbert Weinberg in 1964. (Courtesy Caskey Cunningham.)

The *World Events* sculpture by British-born sculptor Tony Cragg is in the center of the entrance court of the Woodruff Arts Center. The sculpture is 26 feet tall and made of aluminum. The Hudgens family commissioned it on behalf of the Atlanta Committee for the Olympic Games' Cultural Olympiad. (Courtesy Caskey Cunningham.)

This statue is a replica of Leonardo da Vinci's original design for the Sforza family. French invaders destroyed the original, and Charles Dent commissioned another. The Sforza diaspora resulted in a family branch moving to Prague and changing the spelling of their name. Several hundred years later, members of the Storza family moved to Georgia. The Atlanta Botanical Garden grounds, Storza Woods, are named for them. (Courtesy NMF.)

To the left is a bust of Georgia founder James Oglethorpe. At right, Pres. Jimmy Carter was sculpted by Georgia native Frederick Hart, known for the tympanum of the Washington National Cathedral and the Three Soldiers Monument of the Vietnam Memorial. (At left, courtesy Tan Siu; at right, Ken Insley.)

The Woodrow Wilson Monument is located at East Morningside Drive. Wilson spent most of his formative years in Augusta, Savannah, and Atlanta. (Courtesy Caskey Cunningham.)

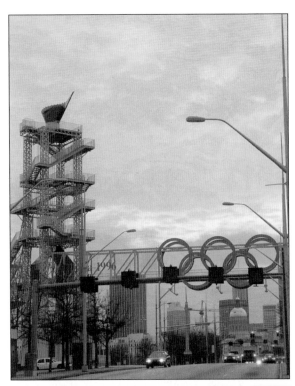

The 1996 Olympic Torch was originally located outside of the Olympic Stadium but was moved one block north. The tower memorializes the 1996 Centennial Olympic Games that took place from July 19 to August 4, making Atlanta the fifth American city to host the Olympic Games. The torch flame was ignited by Muhammad Ali. (Courtesy Tan Siu.)

The Mayor's Grove, a large monument in Piedmont Park near the bathhouse, honors all mayors of Atlanta over the 19th, 20th, and 21st centuries. (Courtesy Caskey Cunningham.)

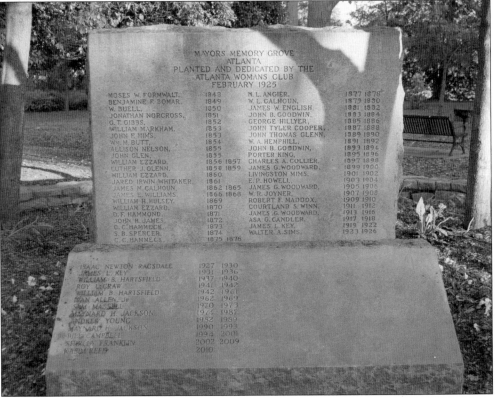

MAYORS MEMORY GROVE
ATLANTA
PLANTED AND DEDICATED BY THE
ATLANTA WOMANS CLUB
FEBRUARY 1925

MOSES W. FORMWALT.	1848		N. L. ANGIER.	1877 1878
BENJAMINE F. BOMAR.	1849		W. L. CALHOUN.	1879 1880
W. BUELL.	1850		JAMES W. ENGLISH.	1881 1882
JONATHAN NORCROSS.	1851		JOHN B. GOODWIN.	1883 1884
G. T. GIBBS.	1852		GEORGE HILLYER.	1885 1886
WILLIAM MARKHAM.	1853		JOHN TYLER COOPER.	1887 1888
JOHN F. MIMS.	1853		JOHN THOMAS GLENN.	1889 1890
WM. M. BUTT.	1854		W. A. HEMPHILL.	1891 1892
ALLISON NELSON.	1855		JOHN B. GOODWIN.	1893 1894
JOHN GLEN.	1855		PORTER KING.	1895 1896
WILLIAM EZZARD.	1856 1857		CHARLES A. COLLIER.	1897 1898
LUTHER J. GLENN.	1858 1859		JAMES G. WOODWARD.	1899 1900
WILLIAM EZZARD.	1860		LIVINGSTON MIMS.	1901 1902
JARED IRWIN WHITAKER.	1861		E. P. HOWELL.	1903 1904
JAMES M. CALHOUN.	1862 1865		JAMES G. WOODWARD.	1905 1906
JAMES E. WILLIAMS.	1866 1868		W. R. JOYNER.	1907 1908
WILLIAM H. HULSEY.	1869		ROBERT F. MADDOX.	1909 1910
WILLIAM EZZARD.	1870		COURTLAND S. WINN.	1911 1912
D. F. HAMMOND.	1871		JAMES G. WOODWARD.	1913 1916
JOHN H. JAMES.	1872		ASA G. CANDLER.	1917 1918
C. C. HAMMECK.	1873		JAMES L. KEY.	1919 1922
S. B. SPENCER.	1874		WALTER A. SIMS.	1923 1926
C. C. HAMMECK.	1875 1876			

ISAAC NEWTON RAGSDALE	1927 1930
JAMES L. KEY	1931 1936
WILLIAM B. HARTSFIELD	1937 1940
ROY LeCRAW	1941 1942
WILLIAM B. HARTSFIELD	1942 1961
IVAN ALLEN, JR.	1962 1969
SAM MASSELL	1970 1973
MAYNARD H. JACKSON.	1974 1981
ANDREW YOUNG	1982 1989
MAYNARD H. JACKSON	1990 1993
BILL CAMPBELL	1994 2001
SHIRLEY FRANKLIN	2002 2009
KASIM REED	2010

Four

ICONIC CORPORATE AND EDUCATIONAL MONUMENTS

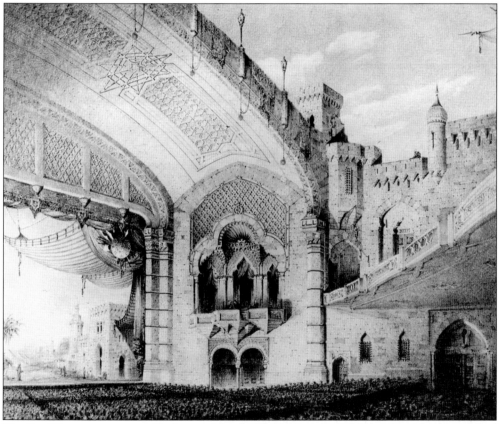

The Fox Theatre was originally designed for the Shriners in the 1920s by the architectural firm Marye, Alger and Vinour. During the Great Depression, Shriners members joined movie mogul William Fox to add a 5,000-seat movie palace, the nation's second largest. The Fox Theatre is the centerpiece of the Fox Theatre Historic District. Its architecture reflects Islamic and Egyptian architectural styles and replicates an Arabian courtyard; the ceiling is a night-sky backdrop for cloud projections and filled with 96 crystal stars. (Courtesy Fox Theatre.)

The Abbey at Westview Cemetery, designed in the Spanish Renaissance style, is one of the most unique buildings in the country. Holding over a 100,000 tombs, the building also has one of the most extraordinary Gothic chapels in the United States. (Courtesy Caskey Cunningham.)

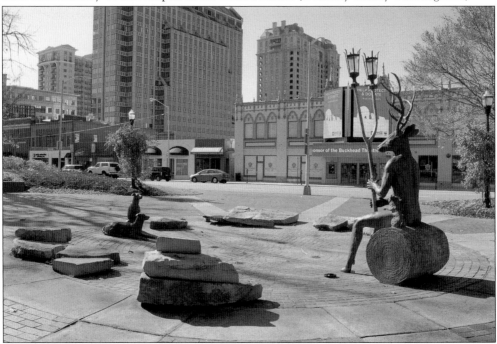

One of the more unusual sculptures in the city is shown here. Buckhead's Loudermilk Park contains the seated buck surrounded by statues of dogs, and it appears the buck is telling them a story. Turtles were once part of this composition but must have wandered away. (Courtesy Caskey Cunningham.)

Rich's department store was one of the most iconic corporate friends any metropolis could possibly have. The traditions and policies of the company endeared it to all the citizens of the city unlike any other company, with the exception of Coca-Cola. (Courtesy GSU.)

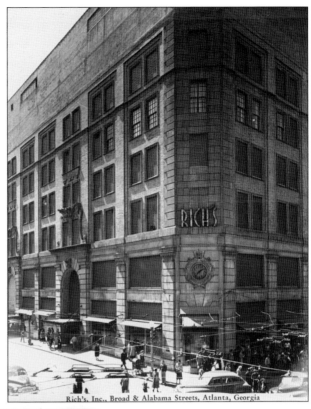

Rich's, Inc., Broad & Alabama Streets, Atlanta, Georgia

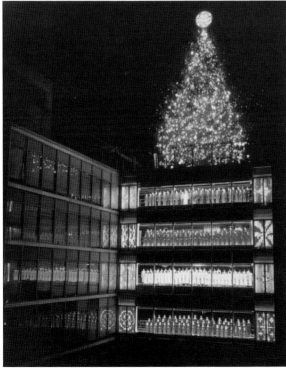

The Rich's Great Tree was among Atlanta's traditions that also included the Pink Pig, an elevated ride for children over the toy department and around the rooftop terraces, allowing the best views of the tree. Thousands would gather below the Crystal Bridge on Thanksgiving night as, beginning from the bottom, each level of the bridge illuminated with a choir singing Christmas carols, culminating with the tree lighting at the top. (Courtesy GSU.)

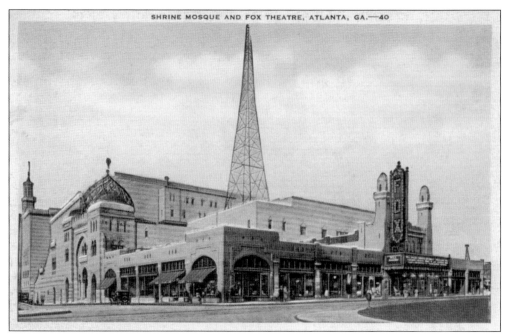

In the 1970s, later owners of the Fox Theatre intended to secretly demolish the landmark in order to sell the land for a corporate headquarters site for AT&T. They were initially stopped by a group of young people called Youth for the Fox, who were alerted to the demolition and staged numerous demonstrations and fundraisers over four years. Atlanta Landmarks, Inc. was formed by citizens to purchase the theater and allow AT&T to build behind it. After restoration began, the theater flourished under Atlanta Landmarks president Beauchamp Carr and is now the most successful theater of its type in the world. It is listed in the National Register of Historic Places and considered a National Historic Landmark. (Courtesy J. Cook.)

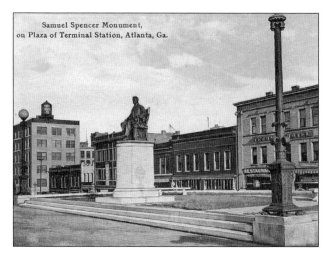

Samuel Spencer Monument, on Plaza of Terminal Station, Atlanta, Ga.

Railroad magnate Samuel Spencer is memorialized by the famous American sculptor Daniel Chester French, who also created the statue of Abraham Lincoln at the Lincoln Memorial in Washington, DC. The statue has been relocated three times around the city and is currently at Fifteenth and Peachtree Streets. Southern Railway employees contributed to the creation of the statue. Spencer was a railway executive and civil engineer; he was president of 6 railroads and a director of 10 others. (Courtesy J. Cook.)

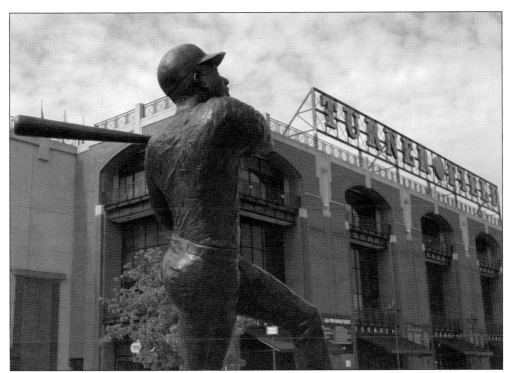

Located at the northern entrance to Turner Field, not far from where this event occurred, the Henry Louis "Hank" Aaron statue replicates Aaron's 715th home run on September 7, 1982, which broke the long-held record of Babe Ruth. The statue is made of bronze and was sculpted by Ed Dwight Jr. (Courtesy Ken Insley.)

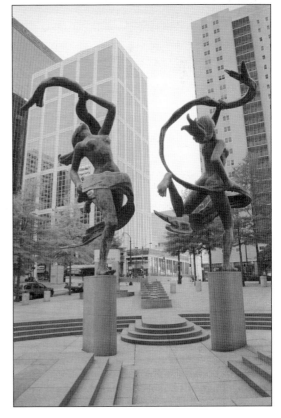

Atlanta architect John Portman Jr. designed and adapted the *Ballet Olympia* from sculptor Paul Manship's *Maenad* as a tribute. The bronze sculptures depict two women dancing with ribbons. Located at SunTrust Plaza on Peachtree Street, they were unveiled in 1992. Manship is noted for his sculpture of Prometheus at Rockefeller Center in New York City. (Courtesy Caskey Cunningham.)

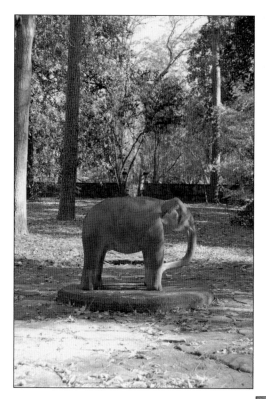

Ambrose the elephant is on the grounds of the Swan House, which was built by Edward and Emily Inman. Atlanta architect Philip Trammell Shutze designed the house and grounds in 1928. The Atlanta Historical Society purchased the home in 1966, and the house was opened to the public in 1967, allowing visitors to tour the house and grounds. It has now expanded to several museum buildings, including the Plantation Plain–style Tullie-Smith House, which was moved and restored under the direction of Bettijo Hogan Cook. (Courtesy Caskey Cunningham.)

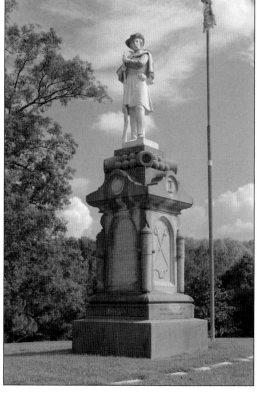

Located at Westview Cemetery, the remains of Confederate Civil War trenches are from the Battle of Ezra Church that occurred on the cemetery grounds. A monument of a Confederate soldier stands at the top of Confederate Knoll, which is the site of 347 Confederate soldiers' graves. It was erected by the Confederate Veterans Association of Fulton County. An inscription on the monument recognizes the value of peace as a result of the nation having more casualties in the Civil War than all other American wars combined. (Courtesy Ken Insley.)

"The Big Chicken," part of a Kentucky Fried Chicken (KFC) restaurant, is an Atlanta landmark (although it is actually located in Marietta). The seven-story-tall chicken, which features a moving beak and eyes, was built in 1963 by Stanley R. "Tubby" Davis, who sold the building to the KFC franchise. This structure is considered by many to be an iconic work. (Courtesy NMF.)

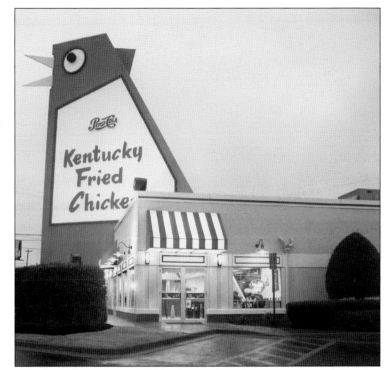

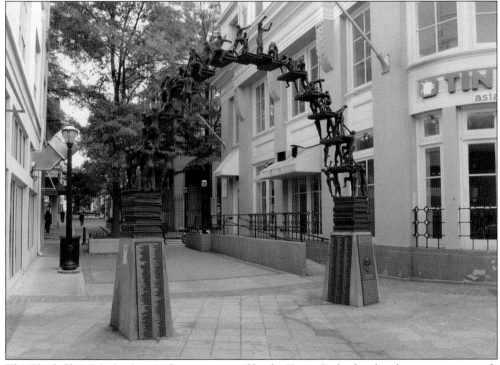

The Chick-fil-A Scholarship Arch was sponsored by the Truitt Cathy family, who are great stewards of education in Georgia. It is adjacent to the Flatiron Building and acts as a gateway between Woodruff Park and the Fairlie-Poplar Historic District. (Courtesy Ken Insley.)

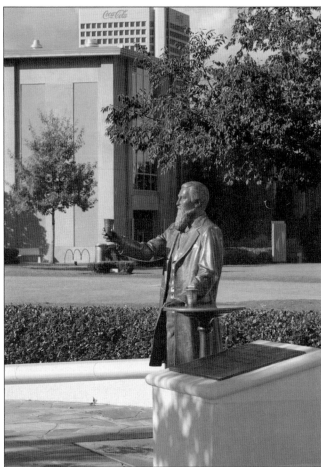

John Pemberton is the Atlanta pharmacist known for inventing the Coca-Cola formula, which he sold to Asa Candler in 1888. Coca-Cola was first served to the public through fountain machines, and the first bottles were sold in 1894. The 800-pound bronze statue was sculpted by Russ Faxon and unveiled outside of the World of Coke Museum in 2007. (Courtesy Ken Insley.)

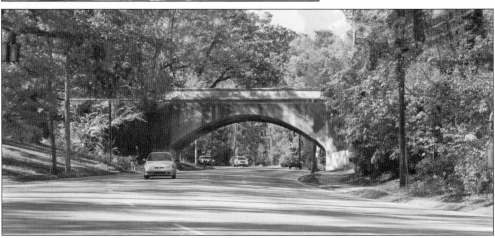

The Druid Hills Gateway Arch is actually a utilitarian bridge for pedestrians and rail. It has been the primary entry into the city from the east since the 19th century, before the construction of the interstate highway system. There are mosaics and decorative elements on the bridge announcing one's arrival at Druid Hills, the elegant residential enclave containing Emory University developed by Joel Hurt and Asa G. Candler. (Courtesy Caskey Cunningham.)

This 60-foot-tall smokestack is a remnant from the original Atlantic Steel mill, which was formerly located on the current site of Atlantic Station in Midtown Atlanta. The smokestack was moved here by the National Monuments Foundation, and at its base are plaques explaining the history of the company and the immediate area. Atlantic Steel, formerly called Dixie Steel, and was the largest steel company in Georgia, drawing more energy from Georgia Power on a daily basis than the city of Macon. (Courtesy Caskey Cunningham.)

The 14-foot-tall bronze sculpture known as *Chaos Mundaka*, located outside of the Savannah College of Art and Design in Atlanta, is by Jedd Novatt. Accepted by SCAD president Paula Wallace, it was donated by Mary Spencer in honor of her husband, Sash Spencer. (Courtesy Caskey Cunningham.)

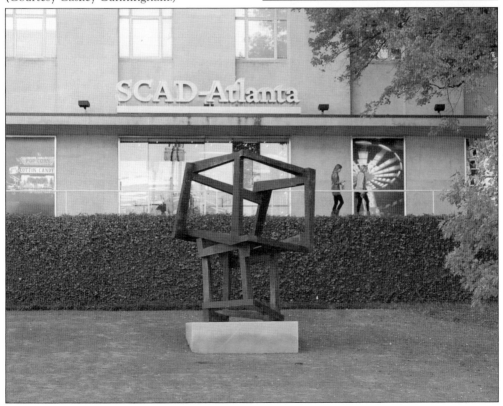

The First National Bank, now called Wells Fargo, commissioned this work of a Phoenix, the symbol of Atlanta, outside its original main offices at 2 Peachtree Street. The phoenix is symbolic of rising again from the ashes, having stood the test of fire. (Courtesy Caskey Cunningham.)

William Candler, son of Coca-Cola magnate Asa Candler, financed the Biltmore Hotel, which opened in 1924. The hotel was once known as the South's supreme hotel, as well as an "apartment hotel" due to the south tower being entirely residential. The New York firm of Schultze and Weaver designed it. The public rooms are so stately and widely used that they have always been considered as an extension of the civic realm. The building was purchased and meticulously restored by Jim Borders of Novarre Corp. (Courtesy Ken Insley.)

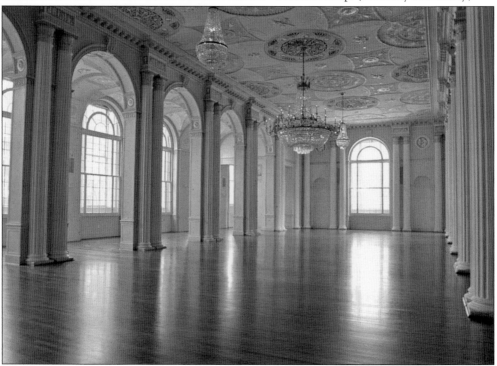

The Academy of Medicine great hall and rotunda by Philip Shutze are a lofty public space enjoyed by the citizens of Atlanta. Beautifully restored by the Georgia Tech Foundation, the complex, which includes a notable theater and audience hall, is in Midtown near the Biltmore Hotel. (Courtesy Susanna Chan.)

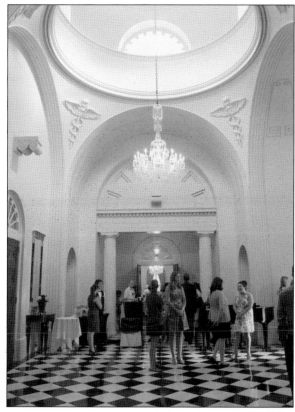

The Fernbank Museum of Natural History atrium is a monumental civic space on its own. It is large enough to comfortably handle the largest dinosaur known to man, as well as a number of his friends. The colossal space was designed by Graham Gund, and the initial interior exhibitions were designed by Ed Schlossberg. (Courtesy Ken Insley.)

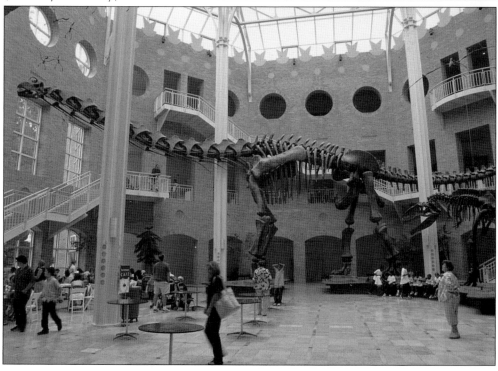

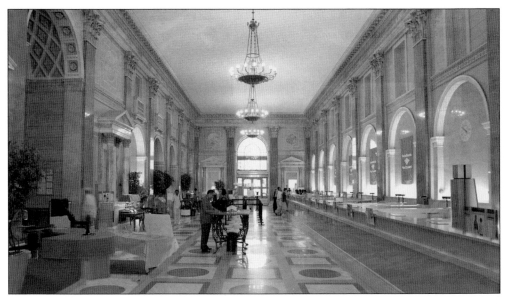

The Citizens and Southern National Bank, now called Bank of America, has a monumental banking room by Shutze at its Five Points downtown headquarters, shown here. The enormous space runs for an entire block and is modeled after the Pantheon in Rome. The banking lobby has been an important interior civic space for over a century. (Courtesy Ken Insley.)

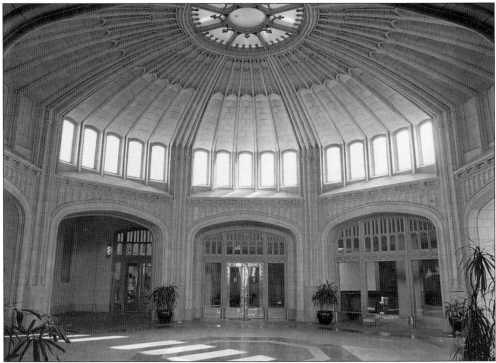

The Healy Building rotunda is also a part of the tradition in Atlanta of having civic realm spaces within private buildings. This monumental Gothic space, central within the Healy Building complex, bisects the block. It allows significant pedestrian access within beautiful architecture, whose clerestory allows ample natural sunlight into this large space. (Courtesy Ken Insley.)

The John Portman–designed Hyatt
Regency Hotel is also within the
tradition as a modern example of the
civic realm being within a private
22-story building. This lobby was a
significant departure from typical
hotel design and set a new standard
for atrium buildings globally. It
has, since opening, remained a
destination for visitors and Atlantans
alike. (Courtesy Tan Siu.)

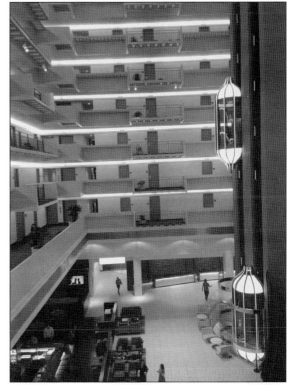

The CNN Center follows in the
footsteps of the Portman reinvention
of the atrium as a giant public space.
This venue is always crowded with
people as they come and go from
various sports arenas and the CNN
Center. (Courtesy Tan Siu.)

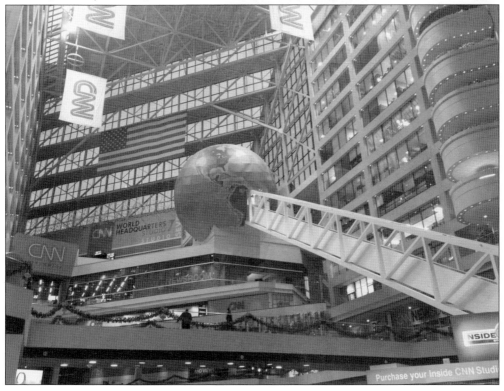

One Ninety One Peachtree Tower is one of the more beautiful skyscrapers in the city. Designed by Johnson Burgee, its pinnacle top evokes the towers at Blenheim Palace in Woodstock, England. Another iconic corporate monumental civic space and a frequent downtown destination, the enormous glass-roofed atrium lobby contains chandeliers copied from those at Grand Central Station in New York. (Courtesy Tan Siu.)

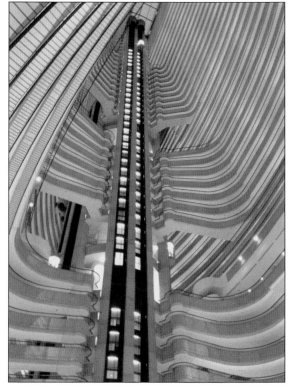

The Marriott Marquis lobby, also designed by John Portman, takes his Hyatt Regency model forward to an extraordinary scale. The structure also bows outward, creating an interior visual experience unlike any public square in the world. As a result, the hotel was the headquarters for the Atlanta Olympic Committee during the Centennial Olympic Games being the loftiest enclosed public space in the city. It was a more than suitable living room for the city of Atlanta to entertain the world. (Courtesy Tan Siu.)

Five

COMMEMORATIVE
MONUMENTS

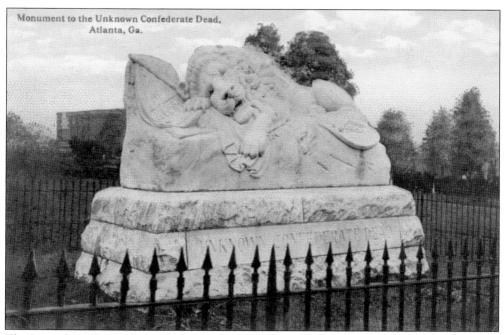

The *Lion of Atlanta* sculpture, based on the Swiss Lion of Lucerne, is a memorial that reminds visitors of the 3,000 unknown Confederate soldiers buried in Oakland Cemetery. The sculpture features a wounded lion laid over a Confederate flag. It was carved in 1894 by T.M. Brady from the largest marble block quarried in Georgia. (Courtesy J. Cook.)

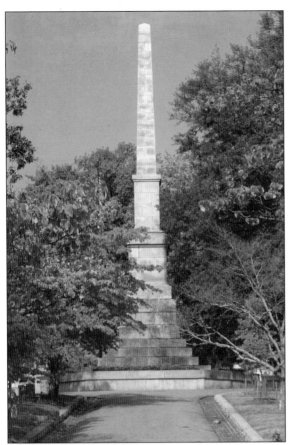

Oakland Cemetery contains the Confederate Memorial Grounds, where over 6,900 Confederate soldiers and 3,000 unknown soldiers have been laid to rest. The Confederate Obelisk stands 65 feet tall and is made of Stone Mountain granite. The obelisk was dedicated by the Atlanta Ladies Memorial Association in 1874 and marks the location of soldiers' graves. The locations of three Confederate generals are northwest of the landmark. (Courtesy Ken Insley.)

This notable statue of railroad tycoon Samuel Spencer faced on axis the Spanish Renaissance Terminal Station. It has been relocated three times and now sits in front of the Norfolk Southern Railroad headquarters at Peachtree and Fifteenth Streets. The base of the statue was designed by noted American architect Stanford White. (Courtesy Kenneth H. Thomas Jr.)

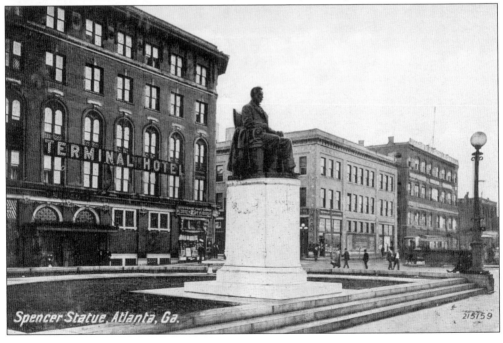

Spencer Statue, Atlanta, Ga.

Georgia's poet laureate Sidney Lanier is honored here on the great ellipse of Piedmont Park. Donated by Mrs. Livingston (Sue Harper) Mims in the 19th century, the memorial is in the form of an Egyptian stelae, and a bust of the poet is recessed, looking west. The bust was restored by the Atlanta Preservation Center and Boyd Coons in 2012 in collaboration with Oglethorpe University Library director Anne Salter and returned to its cenotaph on the center axis of the ellipse. (At right, courtesy GSU; below, Caskey Cunningham.)

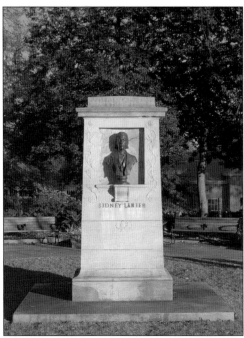

Here is an excerpt from "The Marshes of Glynn" by Sidney Lanier: "Glooms of the live-oaks, beautiful-braided and woven / With intricate shades of the vines that myriad-cloven / Clamber the forks of the multiform boughs,— / Emerald twilights,— / Virginal shy lights . . . The wide sea-marshes of Glynn." (Courtesy Caskey Cunningham.)

The Buckhead-Midtown obelisk commemorates Bess Mims Cook, mother of the Honorable Rodney Mims Cook. The Mims family has impacted Georgia history for over 175 years. The obelisk is at Brookwood Station near where the Mims family home was located. (Both courtesy Caskey Cunningham.)

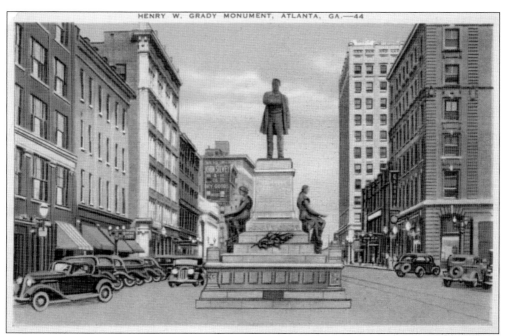

The Henry W. Grady statue sits at the intersection of Marietta and Forsyth Streets in downtown Atlanta. The 25-foot-tall work was unveiled on October 21, 1891. Alexander Doyle sculpted the bronze statue in honor of the visionary journalist who coined the phrase, the "New South." Henry Grady was the editor of the *Atlanta Constitution* newspaper and helped rehabilitate the South after the American Civil War. As a teenager in Georgia, he witnessed some of the most brutal battles of the war. His father was killed by a Union soldier. He bolstered the comparison between the "Old South," which "rested everything on slavery and agriculture, unconscious that these could neither give nor maintain healthy growth," and a "New South . . . thrilling with the consciousness of growing power and prosperity." (Both courtesy J. Cook.)

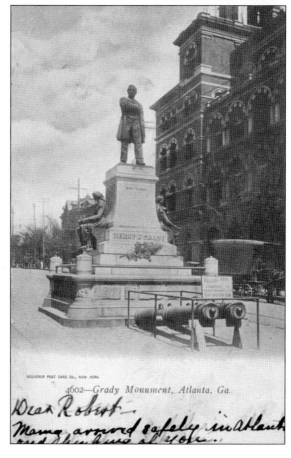

4602—Grady Monument, Atlanta, Ga.

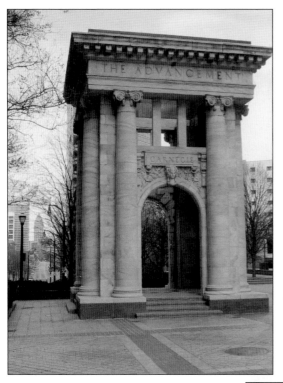

For the Centennial Olympic Games, architect Henri Jova designed the Carnegie Arch for philanthropist Charles Loudermilk. Jova used remnants from the original Carnegie Library at Margaret Mitchell Square, which was torn down in 1977. Located at SunTrust Corporate Headquarters Plaza in Hardy Ivy Park, it is scripted with the words, "Dedicated to the Advancement of Learning," and the names of Carnegie, Aesop, Dante, and Milton are carved in the frieze. (Courtesy of NMF.)

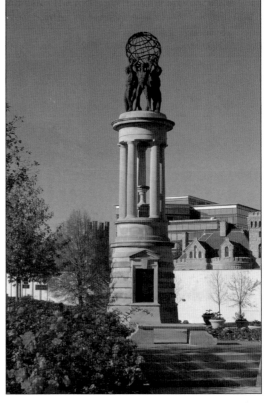

The Prince of Wales Monument, dedicated by Lord Morris representing Queen Elizabeth II, is a gift from His Royal Highness in honor of the Olympics. The Prince's Institute of Architecture American trustee Rodney Mims Cook Jr. held a competition that was won by Russian Anton Glikin. Martin Dawe and Dick Reid created the bronze Atlases with architect Peter Polites and Van Winkle Construction. Georgia Department of Transportation's Wayne Shackelford, through efforts by Mayor Sam Massell, donated land. (Courtesy Caskey Cunningham.)

Steffen Wolfgang George Thomas carved this large stone monument in 1938 in honor of Atlanta's Pioneer Women's Society from 1847 to 1869. (Courtesy Caskey Cunningham.)

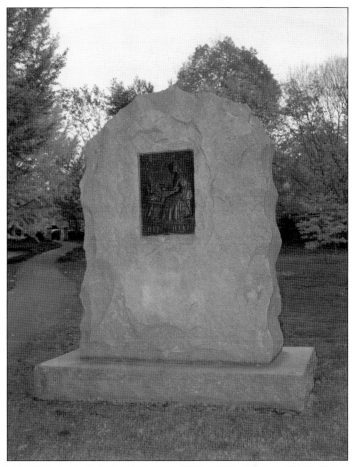

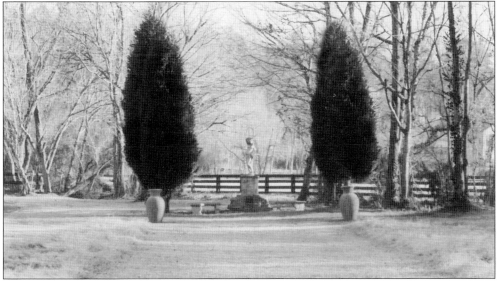

This monument at Alexandra Park is dedicated to Josephine English Cook. It located is at the end of a lawn avenue on axis with a series of fountains and additional monuments. (Courtesy NMF.)

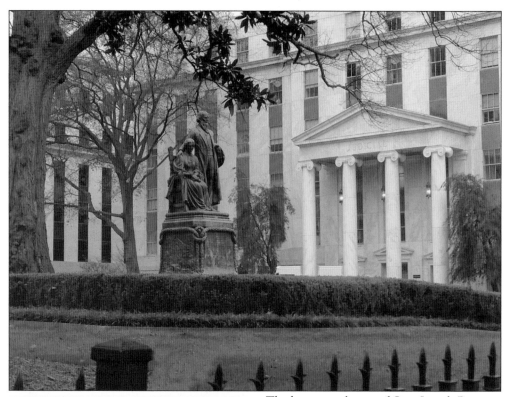

The bronze sculpture of Gov. Joseph Brown on the state capitol grounds also features his wife, who he insisted be included in order to pose for the sculptor. He was Georgia's 42nd governor from 1857 to 1865 and a member of the US Senate from 1880 to 1891. In 1861, Governor Brown pulled his state out of the Union and into the Confederacy. He was a strong believer in state's rights and did not obey national wartime laws or the Confederate military draft. He worked to keep soldiers off the battlefields and in their homes to "fight off invaders." He also criticized Confederate president Jefferson Davis, calling him an incipient tyrant. While shaving in the Governor's Mansion, Brown was arrested personally by Gen. William T. Sherman. (Courtesy Tan Siu.)

The Candler obelisk located at Westview Cemetery is one of many monumental examples of the cemetery's memorials. The obelisk is the tomb of Asa Griggs Candler, Coca-Cola founder and 44th mayor of Atlanta. Candler was one of the pioneer philanthropists of the city. (Courtesy Ken Insley.)

The John F. Kennedy Jr. memorial sits in a bamboo grove at Alexandra Park. Kennedy enjoyed Alexandra Park, particularly this grove. His travels to Georgia were primarily to Cumberland Island, a place he considered personally special, where his marriage to Carolyn Bessette took place. (Both courtesy Caskey Cunningham.)

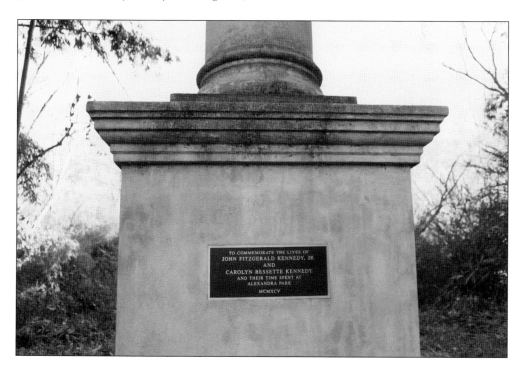

TO COMMEMORATE THE LIVES OF
JOHN FITZGERALD KENNEDY, JR.
AND
CAROLYN BESSETTE KENNEDY
AND THEIR TIME SPENT AT
ALEXANDRA PARK
MCMXCV

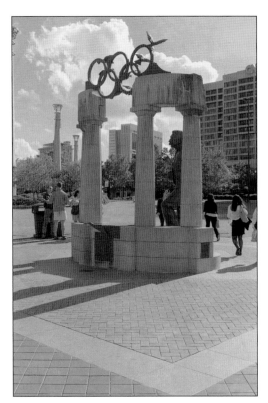

The Baron Pierre de Coubertin statue in Centennial Olympic Park features the French founder of the modern Olympic Games. The statue also includes a step pyramid surrounded by the two pillars of Boaz and Jachin. It was erected in honor of the 100th anniversary of the modern Olympics held in Atlanta. (Courtesy Ken Insley.)

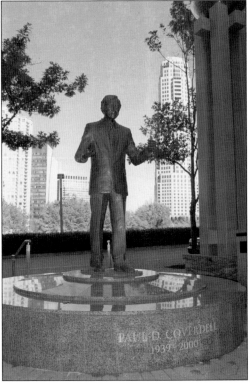

Paul D. Coverdell was elected as a US senator from Georgia in 1992 and again in 1998. He was director of the Peace Corps from 1989 to 1991. His statue is located at Tower Place in Coverdell Park. Senator Coverdell died while in office. A beloved public servant, his body lay in state in the rotunda of the Capitol in Washington. (Courtesy Caskey Cunningham.)

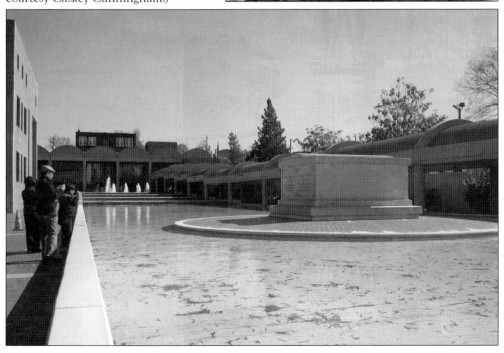

The Martin Luther King Jr. and Coretta Scott King Tomb can be found at the Martin Luther King Jr. National Historic Site in the Sweet Auburn District. King's remains were brought to the tomb in 1977 after being moved from South View Cemetery. His wife, Coretta, was interred here in 2006. The eternal flame of the Nobel Peace Prize laureate encourages vigilance in the pursuit of peace. (Both courtesy Caskey Cunningham.)

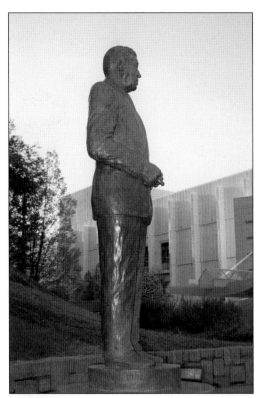

There are two statues of Robert W. Woodruff in the city: one located at Emory University and the other, seen here, at the Woodruff Arts Center. They commemorate the businessman and philanthropist who donated $230 million to Emory University and countless other millions to foster the arts in Georgia, along with his brother George W. Woodruff. Robert was president of The Coca-Cola Company from 1923 to 1954. His legacy as a philanthropist is also due to his great contributions to institutions, colleges, and universities throughout Georgia. (Courtesy Caskey Cunningham.)

The Laura Spelman Rockefeller Memorial was created in October 1918. John D. Rockefeller created the memorial in order to promote the welfare of women and children in honor of his late wife. Laura was a primary contributor to Spelman College, which is named for her family. (Courtesy NMF.)

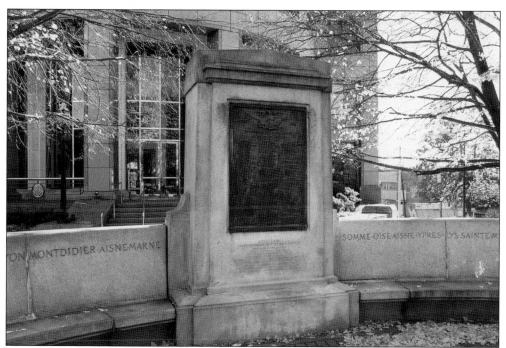

This monument in Pershing Point Park in Midtown is dedicated to Fulton County residents who died in World War I. The plaza where it is located is named after World War I general John Pershing. General Pershing led more troops than any commander in American history. (Courtesy Caskey Cunningham.)

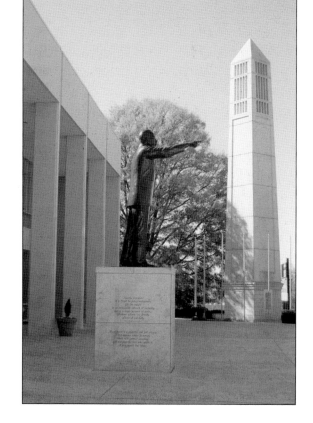

The Dr. Martin Luther King Jr. statue on the plaza of the King Chapel at Morehouse College, his alma mater, is the only statue in the state of Georgia honoring the civil rights leader. It was dedicated in May 1984 and has become a destination for thousands of visitors to the campus. (Courtesy Caskey Cunningham.)

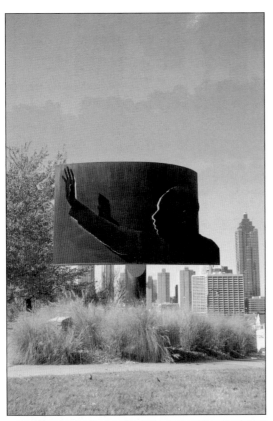

This giant single sheet of Cor-Ten steel cut and formed to the profile of Dr. Martin Luther King Jr. was designed by Palmer Engineering for the Committee for Olympic Development in Atlanta and is located along Freedom Parkway. (Courtesy Caskey Cunningham.)

The statue of Ambassador Andrew Young is found at the corner of Andrew Young International Boulevard and Spring Street. Young was an early civil rights leader and has been a congressman, mayor of Atlanta, and ambassador to the United Nations. Charles Loudermilk, CEO of Aaron Rents, Inc., funded the monument sculpted by John Paul Harris. It was unveiled in April 2008. (Courtesy Ken Insley.)

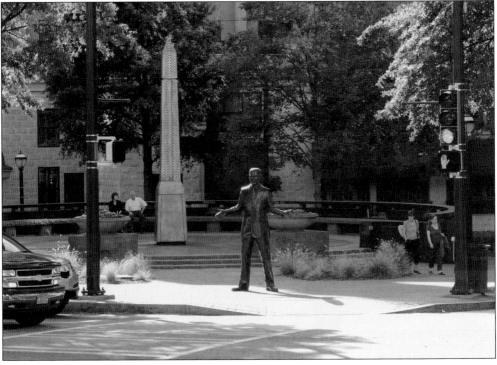

The monument in front of new Ebenezer Baptist Church is called *BEHOLD*. The statue was created by Patrick Morelli and inspired by the African ritual of lifting a newborn to the sky to symbolize that which is greater than yourself. The church was where Martin Luther King Jr. as well as his brother, father, grandfather, and great-grandfather preached. (Courtesy Caskey Cunningham.)

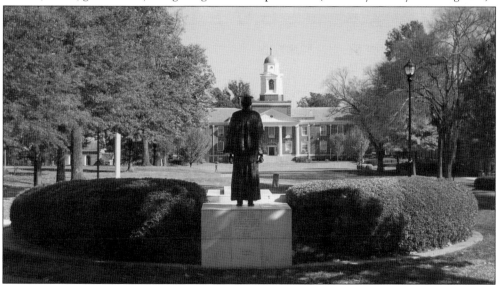

Dr. Benjamin Elijah Mays served as dean of the School of Religion at Howard University from 1934 until 1940 and as president of Morehouse College from 1940 to 1967. Dr. Mays was a mentor to Dr. Martin Luther King Jr. from the time that King was a student until his assassination in 1968. Dr. King considered Dr. Mays to be his spiritual mentor and intellectual father who instilled in his students the dignity of all human beings. He taught the incompatibility of racism and discrimination with the democratic ideals of the US Constitution. These concepts helped inspire the civil rights movement. His statue gazes over his campus and the city beyond. (Courtesy Caskey Cunningham.)

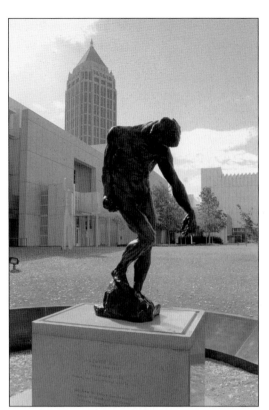

Auguste Rodin's *The Shade* graces Peachtree Street in Midtown. The French government donated the sculpture to the city and the High Museum of Art in honor of Atlanta victims who died from the 1962 Orly plane crash in France, the worst air disaster in history at the time. All Atlantans on the plane were prominent patrons of the arts. (Courtesy Caskey Cunningham.)

US Supreme Court sculptor George Kelly modeled the Washington bronze featured inside the Millennium Gate Museum in Atlantic Station. The Millennium Gate Museum also features 12,000 square feet of gallery space showcasing Georgia history, including a prototype interactive, high-tech exhibit. The Washington bust commemorates George Washington's tours of Georgia. (Courtesy Tan Siu.)

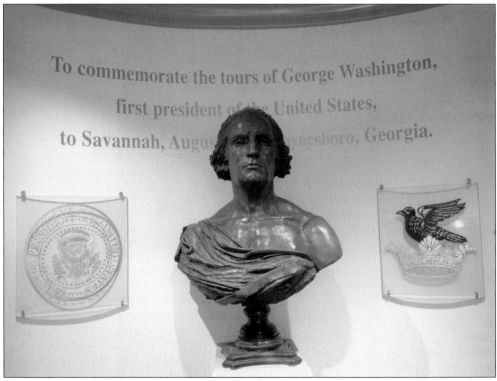

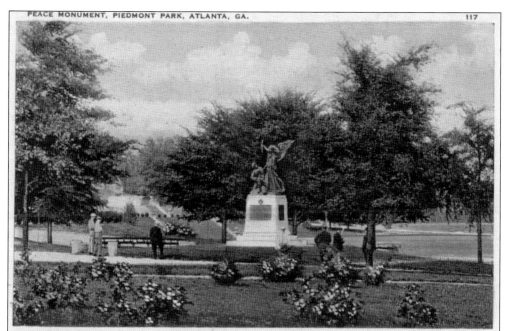

The Peace Monument of the Gate City Guard is located in Piedmont Park at the Fourteenth Street entrance. The statue shows a Civil War soldier sitting below the Angel of Peace, who is raising an olive branch. The monument was dedicated on October 10, 1879, serving as a "Mission of Peace" to the North. Approximately 750,000 people attended the parade, dedication ceremonies, and the unveiling of the monument. (Above, Kenneth H. Thomas Jr.; at right, NMF.)

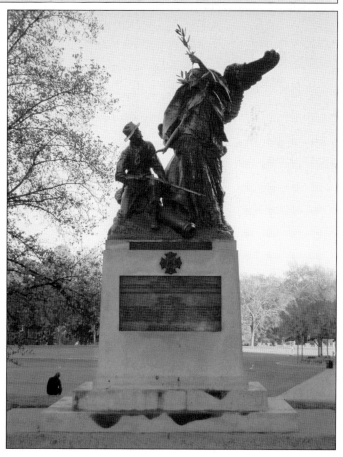

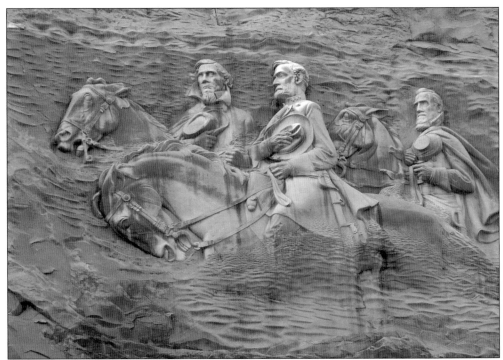

Stone Mountain Park, at a height of 825 feet, is the largest granite outcropping in the world. Carved depictions of Pres. Jefferson Davis, Gen. Robert E. Lee, and Gen. Stonewall Jackson span the length of a football field. It is the largest bas-relief in the world. Gutzon Borglum, who later created the Mount Rushmore Memorial, began developing the bas-relief in 1915. He is seen here (right side of the table, center, with the mustache) having a meal with Virginia governor Elbert Lee Trinkle (right side of the table, second in from the top) and other dignitaries on the shoulder of Robert E. Lee. After altercations between Borglum and the association that hired him, he was fired after completing partial work in 1924. Chief carver Roy Faulkner and several workmen completed the project, and a dedication ceremony took place on May 9, 1970, which was attended by the US vice president. (Above, courtesy NMF; below, Kenneth H. Thomas Jr.)

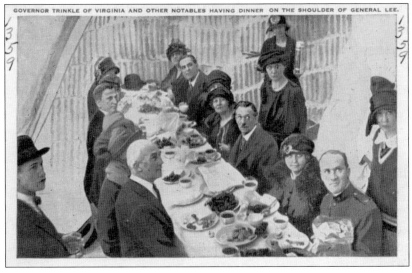

GOVERNOR TRINKLE OF VIRGINIA AND OTHER NOTABLES HAVING DINNER ON THE SHOULDER OF GENERAL LEE.

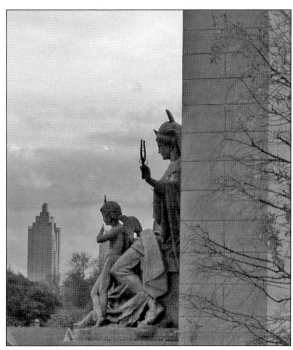

The statues of *Peace* and *Justice* establish the monument precinct at the Millennium Gate in Atlantic Station. They were created by British sculptor Alexander Stoddart. *Peace*, dedicated to Jane Paradise Wolford by her husband, Arol, represents Greece. *Justice*, gifted to the people of Georgia by the Bagwell family, represents Egypt. The arch represents Rome. These three cultures are the pillars of modern civilization. (Both courtesy NMF.)

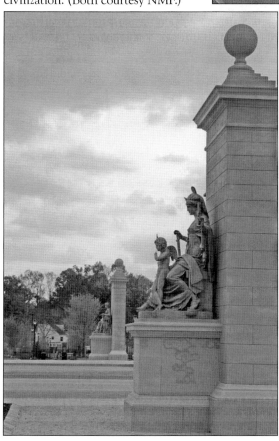

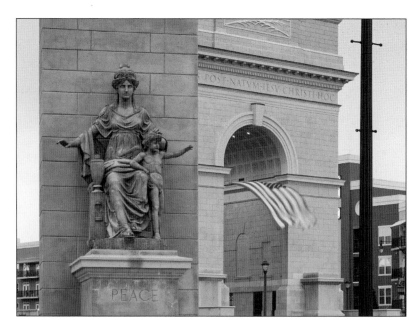

The *Peace* and *Justice* statues at the Millennium Gate won the 2006 Palladio Prize for best American design of a public space. (Courtesy NMF.)

William Porter "Billy" Payne was president and chief executive officer of the Atlanta Committee for the Olympic Games and played a pivotal role in bringing the Olympics to Atlanta in 1996. He first began in 1987 by gaining support of local leaders, including then mayor of Atlanta Andrew Young. Atlanta was selected to host the 1996 Olympic Games by the International Olympic Committee in September 1990. Payne became the first person to lead the bid effort for the games and then stayed on to lead it as the head of the Atlanta Committee for the Olympic Games. His statue is located in Centennial Olympic Park. (Courtesy Caskey Cunningham.)

Six

MONUMENTAL
CIVIC BUILDINGS

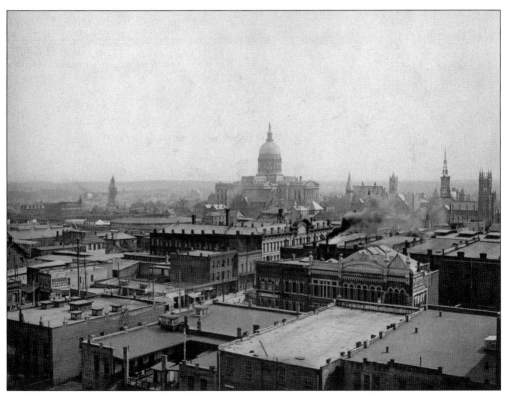

The Kimball Opera House served as Georgia's second state capitol from January 1869 to July 1889. The third and final capitol building is shown here in the Classical Renaissance style, displaying a resemblance to the US Capitol. The designers of the building were Willoughby J. Edbrooke and Franklin P. Burnham. The interior consists of 1.5 acres of Georgia marble. Under the rotunda are portraits and statues of notable Georgia citizens and Georgia's signers of the Declaration of Independence. (Courtesy AHC.)

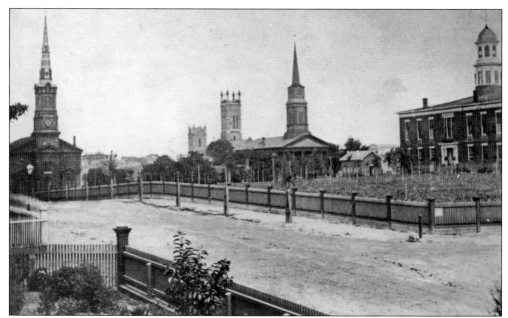

The Georgia Constitution was ratified in April 1868 as a result of a state convention's agreement, and Atlanta was designated as Georgia's new state capital city. The city chose to offer the Atlanta City Hall–Fulton County Courthouse (above right with cupola) as the new Georgia State Capitol, and on July 4, 1868, the general assembly held its first meeting in its new headquarters. This building was only used for six months. From left to right are the Second Baptist Church, the Immaculate Conception Church, the Central Presbyterian Church, and the Atlanta City Hall–Fulton County Courthouse/state capitol. Atlanta's sixth mayor, John Mims, donated the land to the city for this use. (Courtesy AHC.)

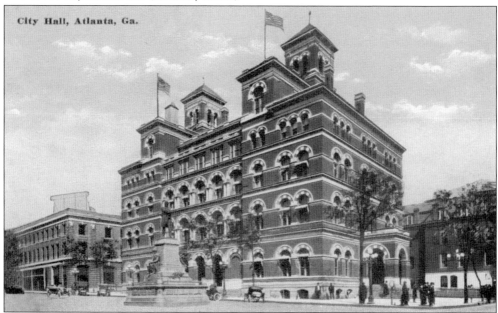

City Hall, Atlanta, Ga.

The third city hall building was located in the old post office and customs house at Marietta and Forsyth Streets from 1911 to 1930. (Courtesy Kenneth H. Thomas Jr.)

The current Atlanta City Hall building was designed by architect G. Lloyd Preacher in the Late Gothic Revival style and erected in 1930. The building is Atlanta's fourth city hall and is the site of the Neal mansion used by General Sherman as his headquarters during the Battle of Atlanta. City hall is listed in the National Register of Historic Places. (Courtesy J. Cook.)

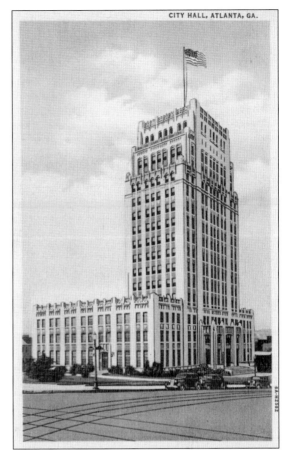

The US pavilion at the 1895 Cotton States and International Exposition is seen from the Exedra terrace, on top of which now sits the Sidney Lanier Monument. The buildings are gone, but the terraces remain. (Courtesy AHC.)

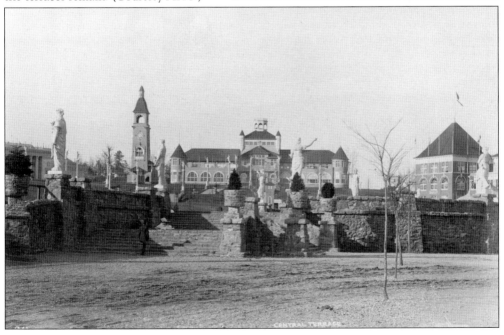

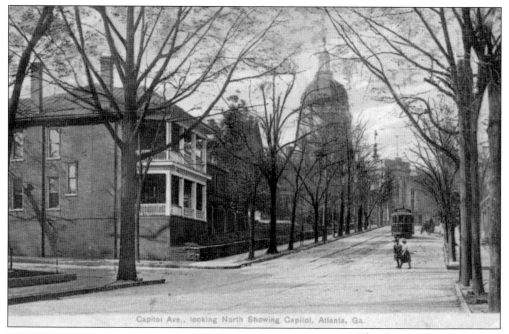

Capitol Ave., looking North Showing Capitol, Atlanta, Ga.

The Georgia State Capitol building has been named a National Historic Landmark and is listed in the National Register of Historic Places. It acts as an office building for the governor, lieutenant governor, and secretary of state and is the home of the Georgia General Assembly. The difference in the growth of the city is very tangible in these two images showing the capitol from the same vantage point over the period of approximately a century. (Above, courtesy Kenneth H. Thomas Jr.; at left, L. Robertson.)

Restoration of the capitol began with the establishment of the Commission for the Preservation of the Georgia State Capitol in 1993. Lord, Aeck & Sargent was chosen in 1996 as the architectural firm for the restoration. The rotunda and public corridors were first to be restored. (Courtesy Tan Siu.)

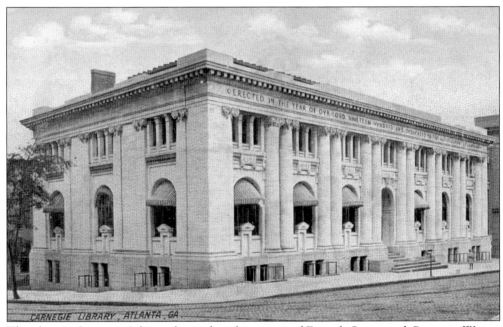

The elegant Carnegie Library, located at the corner of Forsyth Street and Carnegie Way at Margaret Mitchell Square, was the first Atlanta-Fulton Public Library, which opened on March 4, 1902. The Young Men's Library Association, City of Atlanta, and Andrew Carnegie worked on its development. After renovations in the 1950s, the library was renamed the Atlanta Public Library. The Central Library replaced the Carnegie Library when it was torn down in 1977. It exists in part as a triumphal arch at Hardy Ivy Park (see chapter five). (Courtesy Kenneth H. Thomas Jr.)

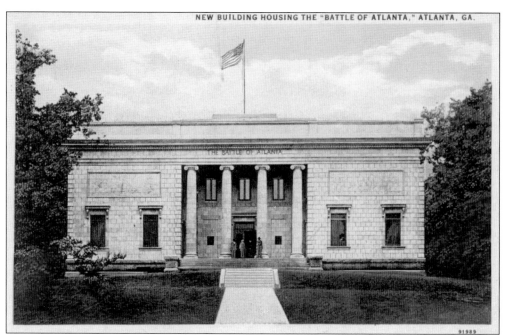

The Atlanta Cyclorama and Civil War Museum is located in Atlanta's historic Grant Park. The museum houses artifacts from the American Civil War, including a steam locomotive from the Great Locomotive Chase of 1862. It offers guests the opportunity to "relive the Battle of Atlanta," fought on July 22, 1864, by experiencing the cyclorama oil painting and diorama, said to be the largest of its kind in the world. A theater in the round rotates, allowing visitors to experience the battle at its most intense moment. (Courtesy J. Cook.)

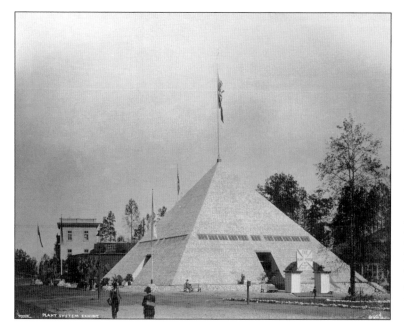

Atlantans have always had an interest in exotic architecture styles, including Moorish, Islamic, Rococo, Baroque, Spanish Renaissance, and many others. This Egyptian pyramid, which was also a power station, is no exception. (Courtesy AHC.)

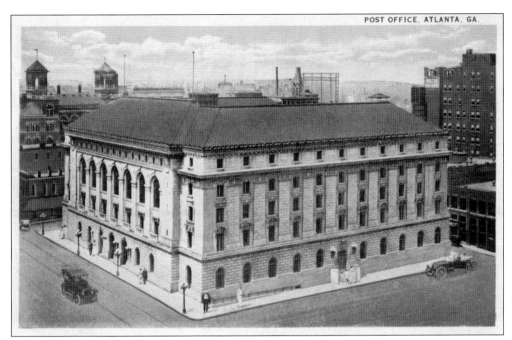

Located in the Fairlie-Poplar Historic District, the Tuttle Court of Appeals (named in honor of Judge Elbert P. Tuttle) was originally occupied by the Eleventh Circuit Court of Appeals. It was designed in the Second Renaissance Revival style by architect James Knox Taylor and built in 1910. In 1974, it was listed in the National Register of Historic Places. (Courtesy Kenneth H. Thomas Jr.)

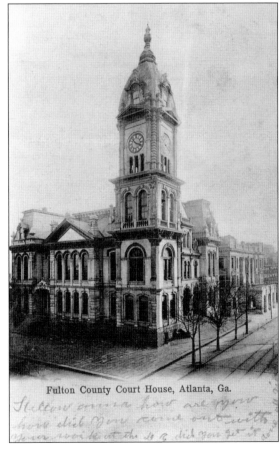

Fulton County Court House, Atlanta, Ga.

Planning for a new Fulton County Courthouse began in 1877. The Georgia General Assembly, per request by Fulton County officials, passed legislation allowing the county to levy a special tax to pay for the new building. The two-story redbrick courthouse featured a prominent clock tower and was completed in 1882. (Courtesy AHC.)

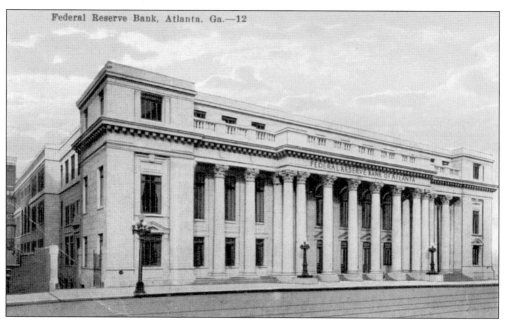

The Federal Reserve Bank, initially located on Marietta Street (above) and now on Peachtree Street (below) in Midtown Atlanta, is responsible for monetary policy, operating the nationwide payment system, and for bank supervision and regulation of the Sixth District. The district includes branches in Atlanta, Miami, Jacksonville, Nashville, and New Orleans. The eagle statue located in front of the building was commissioned by the bank and designed by American sculptor Elbert Weinberg. The freestanding columns that grace the plaza of the current bank are remnants of the Marietta Street bank building. (Above, courtesy Kenneth H. Thomas Jr.; below, Caskey Cunningham.)

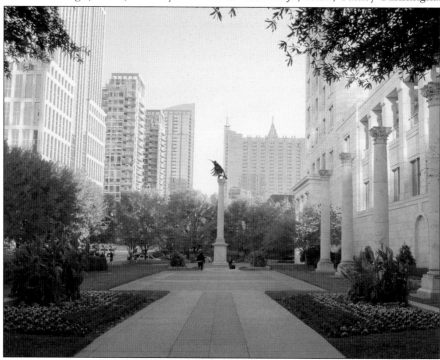

This nighttime photograph is of the Chimes Tower and Fine Arts Building at the 1895 Cotton States and International Exposition that occurred in Piedmont Park. It was one of the first events in history to be electrified. (Courtesy AHC.)

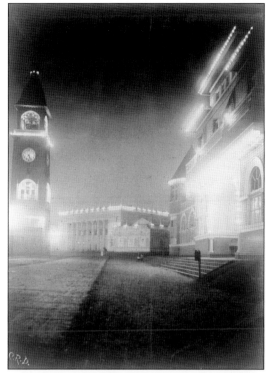

The Electricity Building at the 1895 Cotton States and International Exposition had to be the most magical-looking building at night. The fair was one of the first electrified events in world history, and the Electrical Building at the fair had a major role in promoting the future of that utility. (Courtesy AHC.)

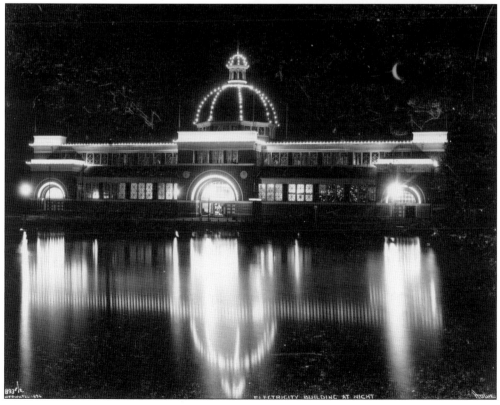

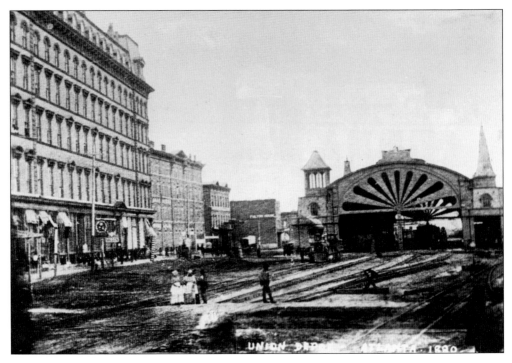

The center of Atlanta developed around the railroad, and the early Terminal Station with its magnificent fan arch is seen above. The Kimball House Hotel, the finest hotel in the city at the time, is left of the station. An updated glazed arch was created years later, as seen in the image below. Eventually, street traffic backed up when trains rumbled through downtown, creating a need to elevate the streets over this area, which helped bring about Underground Atlanta. (Above, courtesy AHC; below, Kenneth H. Thomas Jr.)

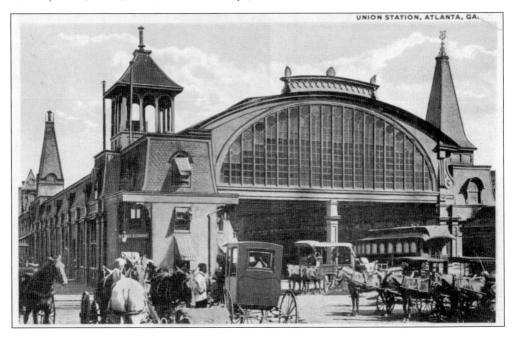

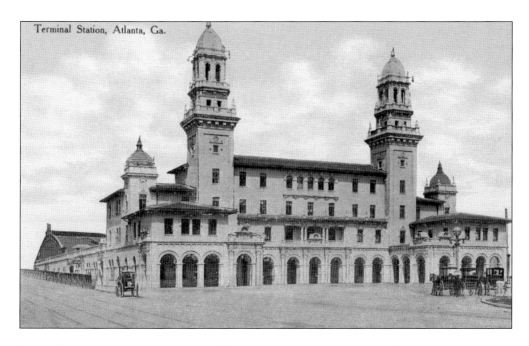

Terminal Station, Atlanta, Ga.

Located on Spring Street downtown, the new Terminal Station opened in May 1907. Built by Mayor James English, the station was one of the most important terminal buildings in the United States. Atlanta was initially established because of railroads and remains to this day one of the more important transportation centers in the world. The notable statue of Samuel Spencer by Daniel Chester French faced the building on the center axis. The station was demolished in 1972. Architect P. Thornton Marye designed it in the Spanish Renaissance style. The Richard B. Russell Federal Building is now located on the Terminal Station site. (Both courtesy J. Cook.)

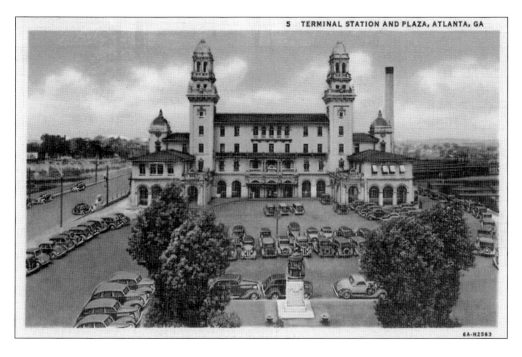

5 TERMINAL STATION AND PLAZA, ATLANTA, GA

6A-H2563

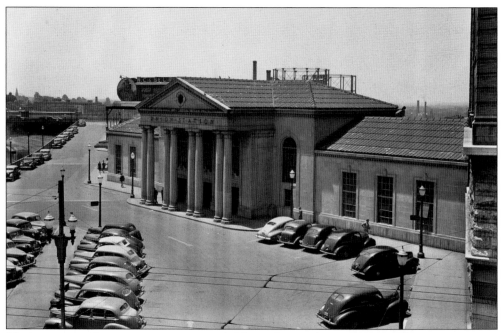

The city required two major stations, with Union Station being the second most important. The station site was located between Forsyth and Spring Streets. It opened in 1930 and ceased operating in 1971; it served many railroads, including the Georgia, the Atlantic Coast Line, and the Louisville & Nashville Railroads. (Courtesy GSU.)

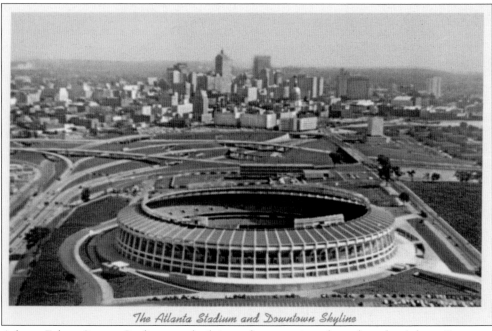

The Atlanta Stadium and Downtown Skyline

Atlanta-Fulton County Stadium was built in under a year in order to lure the Atlanta Braves to the city. The structure seated over 55,000 people and was the site of the famous 715th home run of Hank Aaron, surpassing the record of the legendary Babe Ruth. The building has been torn down and replaced by Turner Field. (Courtesy J. Cook.)

The Fine Arts Building at the 1895 Cotton States and International Exposition was a highly praised structure in the Beaux-Arts style designed by W.T. Downing. Portions of the Piedmont Driving Club sit on this site today, and the monumental ballroom of the club was a part of the fair's buildings. The Fine Arts Building was on a promontory at the top of a gigantic staircase, which was framed by freestanding monumental columns topped with gilded statuary. It was following in the tradition of the great White City that was part of the Chicago Exposition held just a few years prior. (Both courtesy AHC.)

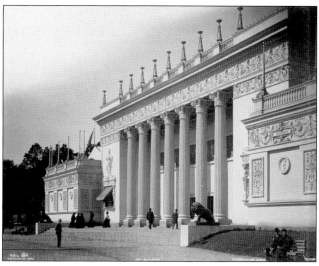

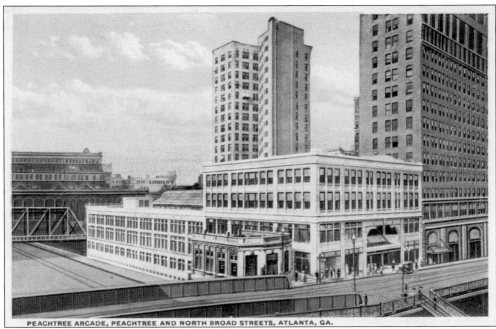

PEACHTREE ARCADE, PEACHTREE AND NORTH BROAD STREETS, ATLANTA, GA.

The Peachtree Arcade was Atlanta's first shopping mall. It was a cast-iron structure with a glazed roof on multiple levels. The building faced Plaza Park, both of which were elevated over the railroad. Peachtree Arcade was a block from Rich's department store, two blocks from Muses Clothing Store, three blocks from Brooks Brothers, and four from Davison's department store. It was the heart of the downtown shopping district. (Above, courtesy J. Cook; below, AHC.)

The beautiful Neoclassical Machinery Hall at the Cotton States and International Exposition was one of the more theatrical electrified buildings at the exposition. The structure faced Lake Clara Mere, creating a breathtaking reflection for fair patrons at night. (Courtesy AHC.)

The opening of Lakewood Park in 1893, situated on land previously owned by Muscogee Indians, led to the occurrence of the Southeastern Fair in 1915. The Lakewood Speedway was built on the property in 1938. The 1980s brought a motion-picture complex that complements the California Mission–style architecture. An antique mall and amphitheater also came to the park grounds after the Southeastern Fair and the Lakewood Speedway ceased operations. (Courtesy GSU.)

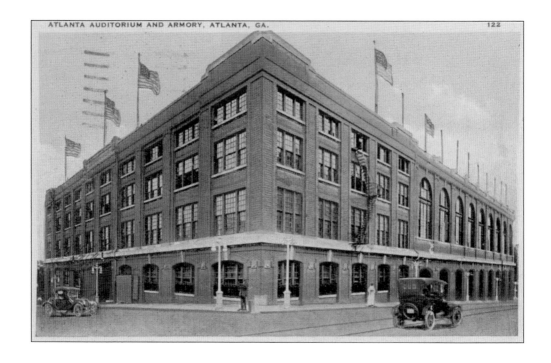

The massive Atlanta Auditorium and Armory was a functional barn of a convention center that, despite its unsophisticated appearance, loaded people into the downtown area and provided Atlanta its beginning as a national convention center. (Both courtesy J. Cook.)

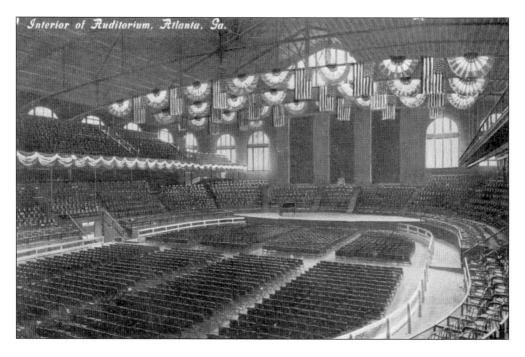

Interior of Auditorium, Atlanta, Ga.

The Cotton States and International Exposition, as mentioned earlier, had numerous monumental buildings. This view looks south toward the Georgia Pavilion where the famous "Atlanta Compromise" speech was made by Booker T. Washington on September 18, 1895. Organizers of the exposition were apprehensive to invite an African American speaker to an event where white visitors were the majority but decided that it would showcase racial progress in the South and would impress exposition attendees. Washington's speech was one of the most important and influential in American history. (Courtesy AHC.)

Amos G. Rhodes was in partnership with J.J. Haverty, having formed the Rhodes Haverty Furniture Company. After their retirement, just for fun, they built the Rhodes Haverty Tower, the tallest building in the South at the time. Rhodes began to build this monumental residence at the end of the 19th century on Peachtree Street in Midtown, moving there in the early part of the 20th century. Residential Peachtree Street once competed with Victorian Fifth Avenue as home to the grandest chateau, palace, or castle, yet it is now a very urban district. Only a few remain, and Peachtree Street has been described by former *New York Times* architecture critic Paul Goldberger as "Wilshire Boulevard with a southern accent." Rhodes Hall is currently the headquarters of the Georgia Trust for Historic Preservation and has been meticulously restored. (Courtesy NMF.)

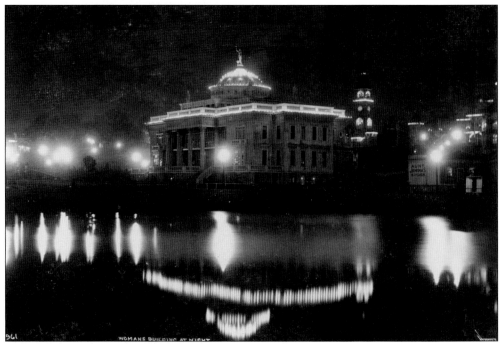

Seen across Lake Clara Mere at night, the beautifully electrified, domed Women's Building provides a showcase for the achievements of women in the modern era. Such a prominent position across the Grand Ellipse from the main gates indicates the forward-thinking approach the City of Atlanta was fostering as the capital of the "New South." (Courtesy AHC.)

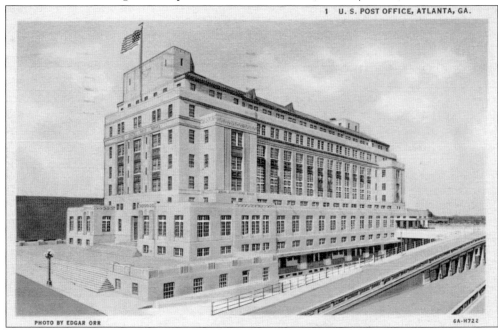

The Art Deco–style US post office at Spring Street is still one of the larger office buildings in the city. The Atlanta Terminal Station originally stood across the street from this building. (Courtesy J. Cook.)

The rostral statue–topped columns and the Chimes Tower at the 1895 Cotton States and International Exposition are a striking disconnection of classical versus Victorian architecture; however, the contrast was irrelevant to the nearly one million people who attended the entertaining event. (Courtesy AHC.)

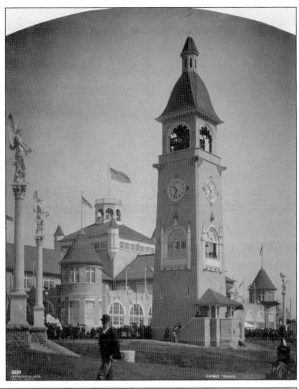

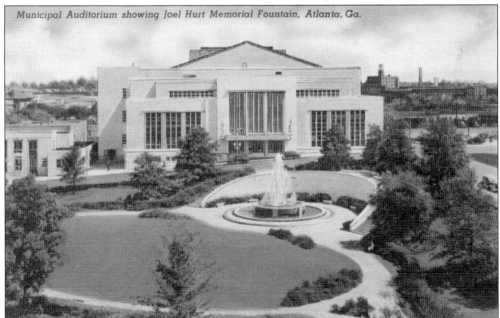

Hurt Park and Municipal Auditorium opened in 1940 and acted as the Atlanta Civic Center for 30 years. Landscape architect William C. Pauley designed Hurt Park and fountain, which was one of the only construction projects during the Great Depression in downtown Atlanta. It was named after Joel Hurt, one of Atlanta's and Georgia's most notable philanthropists. (Courtesy J. Cook.)

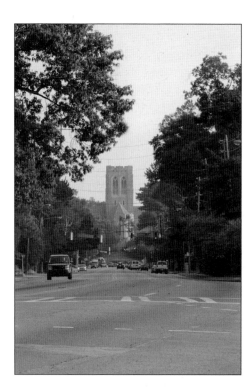

The Cathedral of St. Philip is the oldest Episcopal denomination in Atlanta, having been established in 1846 across from the capitol. The cathedral now sits on a promontory on axis with Peachtree Road. The Gothic building has some of the most beautiful stained-glass windows in the city. (Both courtesy Ken Insley.)

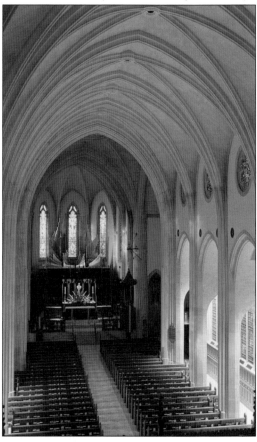

Seen in front are the Very Reverend Sam Candler (center), dean of the Cathedral of St. Philip, and his friend Robert Willis (right), dean of Canterbury Cathedral. They are with Jim Jacoby (left), who is driving a team of horses carrying the *Peace* and *Justice* statues to their permanent location in Atlantic Station. (Courtesy NMF.)

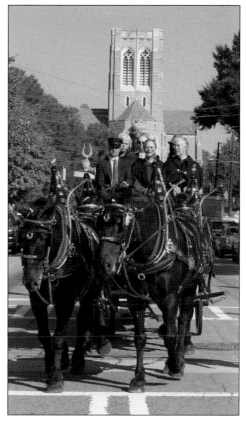

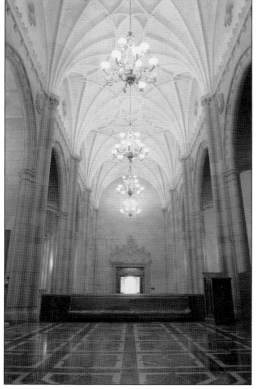

The 12th-century Spanish Renaissance–style Westview Abbey at Westview Cemetery was built in 1943. The mausoleum contains room for more than 100,000 tombs. Inside, the mausoleum chapel contains murals of Faith, Hope, and Charity, an intricately carved-wood altar, and stained-glass windows. (Courtesy Ken Insley.)

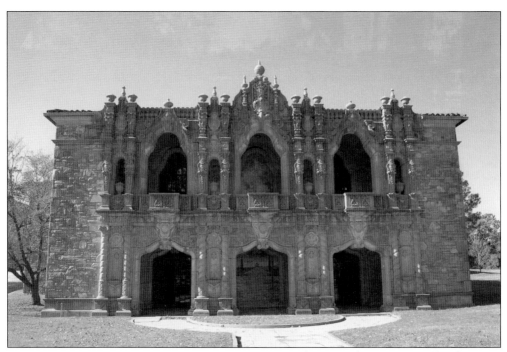

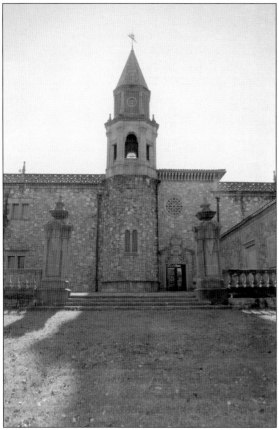

The Spanish Rococo east facade contains the great seals of both the state of Georgia and the city of Atlanta. The campanile is situated on a vast terrace surrounded by a balustrade. The bells can be heard for blocks. (Both courtesy Caskey Cunningham.)

Seven

ROYAL AND PHILANTHROPIC COLLABORATIVE PARKS AND MONUMENTS

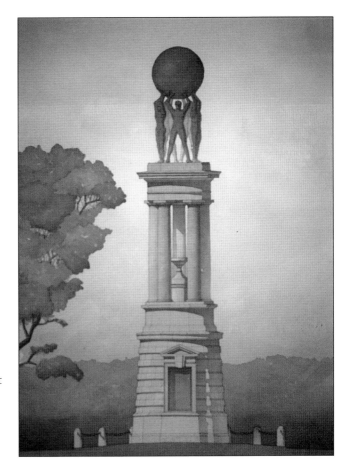

The Prince of Wales's World Athletes Monument was built to commemorate the 1996 Centennial Olympic Games. It is topped by five Atlas figures that were sculpted by the celebrated Dick Reid of York, England, and Martin Dawe of Atlanta. (Courtesy NMF.)

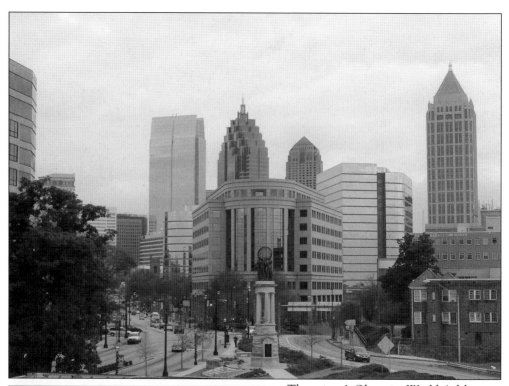

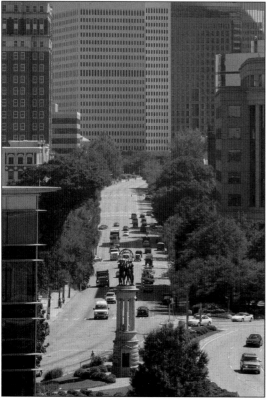

The prince's Olympics World Athletes Monument is one of only four monumental buildings in the city that enjoys a monumental axis with its street approach. The Olympics statue is also aligned with the 19th-century, Gothic Peachtree Christian Church bell tower, from which this image was taken; the intention being that they were done simultaneously during the Beaux-Arts City Beautiful movement. The other three axial-aligned monuments and streets are the Cathedral of St. Philip and the Carnegie Library arch (both on Peachtree Street) and the Millennium Gate (on Seventeenth Street). (Above, courtesy NMF; at left, Emily Robinson Cook.)

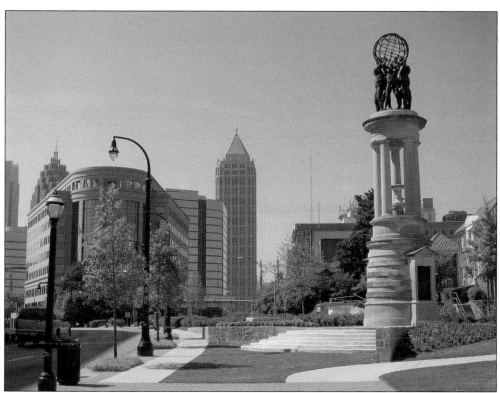

CNN estimated that 30,000 people were drawn to the World Athletes Monument during several days of international mourning for Diana, Princess of Wales. In addition, thousands returned with flags, candles, flowers, and mementos, placing them around the monument after the death of Pres. Ronald Reagan in 2004. Local news media covered the events, indicating it was a unique cultural work of art, which the citizens of Atlanta have embraced as a place for healing. (Both courtesy NMF.)

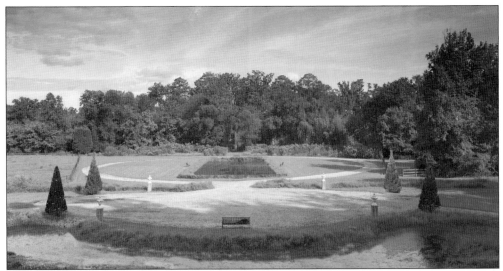

Alexandra Park is the largest animal sanctuary in the city and has extended vistas that are complimented by statuary and follies. The original park was laid out by the Elsas and Storza families, who were involved with the Atlanta Botanical Garden as well as equestrian life in Georgia. William Pauley was instrumental in the design of the park, and Spencer Tunnell complimented that design a generation later. (Courtesy Emily Robinson Cook.)

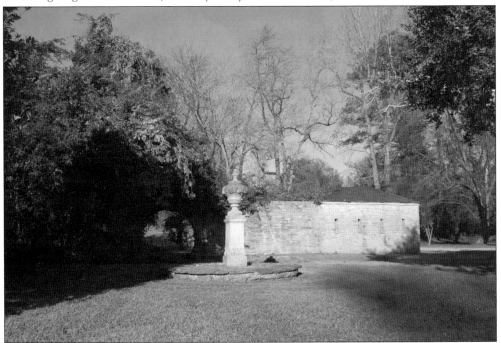

The Moon Gate forms the entrance into a Japanese garden by William Pauley. The garden is on a peninsula, and all plant species are of an Asian variety. The Atlanta Botanical Garden has monitored the success that these non-indigenous plants have enjoyed in a southern climate. The Asian bamboo at Alexandra Park is what saved the panda bears from hunger when they first arrived in the city, as they disliked native bamboo. The bamboo groves were harvested by Zoo Atlanta, and the pandas are now happy. (Courtesy Emily Robinson Cook.)

This monument was erected at Princess
Diana Memorial Plaza at Pershing Point
by the Prince of Wales's Foundation
for Architecture to commemorate the
Centennial Olympic Games. It was
surmounted by five bronze figures of Atlas
that are now positioned on the permanent
monument, which replaced this model.
The work was unveiled on August 2, 1996,
and was moved to Alexandra Park in 1997.
(Both courtesy Emily Robinson Cook.)

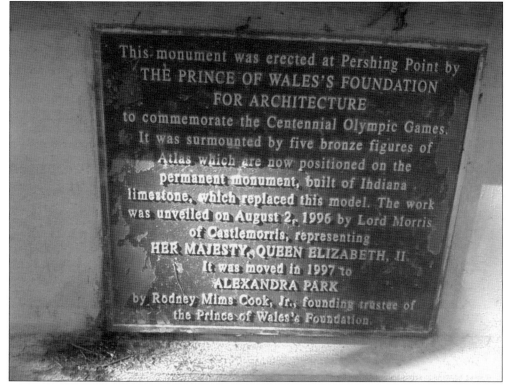

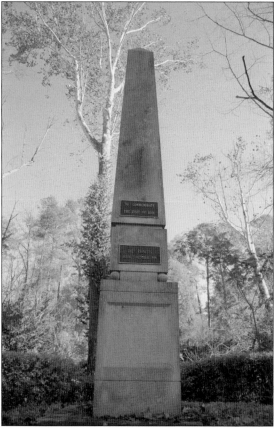

This obelisk commemorating the millennium was dedicated by Her Royal Highness, Anne, Princess Royal, in 2000. Princess Anne has had a long-standing relationship with Atlanta since the 1996 Olympic Games, when she represented Great Britain in equestrian events. The Princess Royal Monument is at the end of a long canal at Alexandra Park and aligns perfectly with the sunrise on June 16. (Both courtesy NMF.)

The Princess Royal dedicated this monument with a very good bottle of champagne, which she was able to smash on the first try. (Courtesy NMF.)

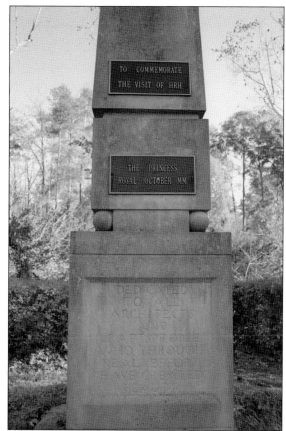

The Wolford Garden in Druid Hills is a former estate of the family who built Retail Credit Company, now called Equifax. The gardens are open to the public, and the mansion house still stands. This view is of the main lawn surrounded by a trellised colonnade. Azaleas and other flowering plants decorate this beautiful, formerly private, park. (Courtesy Caskey Cunningham.)

Numerous trails and waterways meander throughout the extensive garden, which also contains a series of follies; this bridge is one of them. The Wolford Casino is an Italian-style folly at the end of one of the garden parterres. It leads to a grand staircase that climbs to a sweeping lawn, which rises to the former Wolford Mansion. (Both courtesy Caskey Cunningham.)

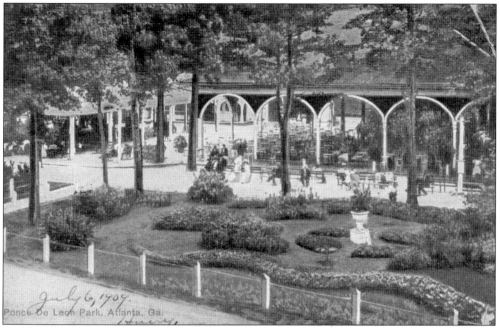

The Ponce de Leon Amusement Park and Gardens, established at the end of the 19th century, provided the Atlanta public with a gathering place for weekend performances, concerts, picnics, and more. (Courtesy Kenneth H. Thomas Jr.)

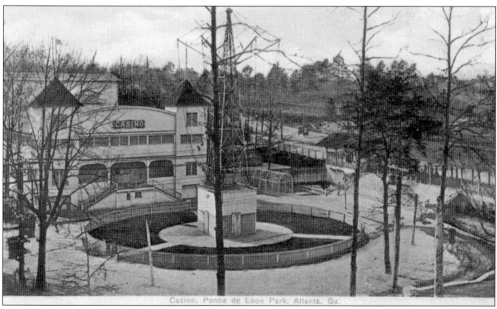

The Ponce de Leon Amusement Park and Gardens also featured great technological advances of its time and entertained the public with attractions like the Ferris wheel, giant swing, Shoot the Chute, and a scenic railway. (Courtesy Kenneth H. Thomas Jr.)

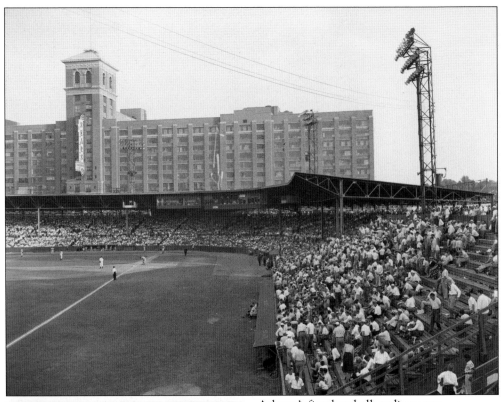

Atlanta's first baseball stadium was developed on the site of the Ponce de Leon Amusement Park in 1907. The Atlanta Crackers, the predecessors to the Atlanta Braves, played there. (Courtesy AHC.)

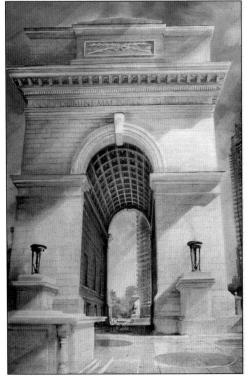

The Millennium Gate, a 100-foot-tall monumental arch, is situated on axis with Seventeenth Street in Atlantic Station. Comparisons can be made to the Washington Arch in New York, the Wellington Arch in London, and the Titus Arch in Rome. (Courtesy NMF.)

The Millennium Gate is situated in a five-acre park with a three-acre lake. Embellished with sculptural allegory presenting the story of peaceful accomplishment over the last 2,000 years, it was the largest public monument built in America since the Jefferson Memorial. It is the headquarters of the National Monuments Foundation and contains an extensive museum of Georgia history. (At right, courtesy of Ken Insley; below, Gaurav Kumar.)

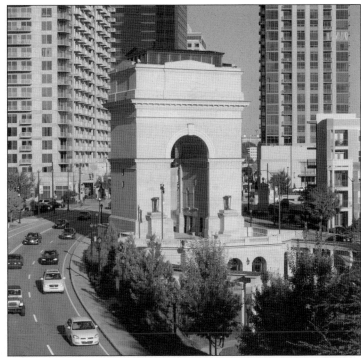

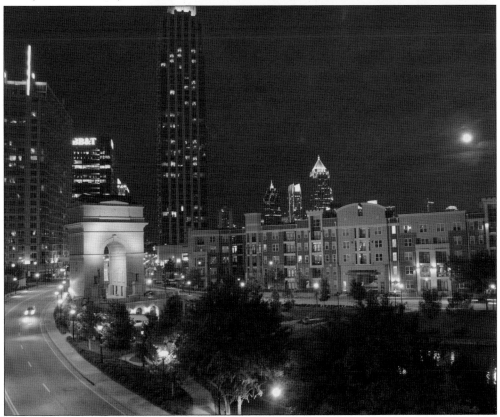

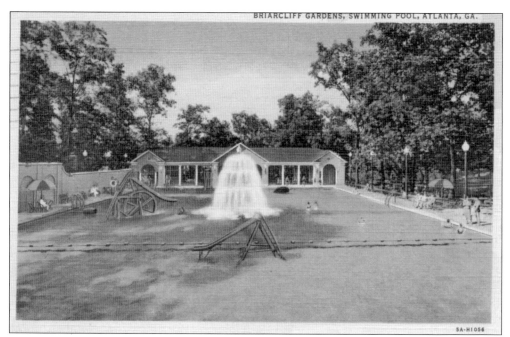

Briarcliff Gardens were a part of Briarcliff Manor, the residence of Asa Griggs Candler Jr. A private zoo was located on this estate, which later was donated and became Zoo Atlanta in Grant Park. The Olympic-size swimming pool seen here was built for the residents of the city to use at their leisure. (Courtesy Kenneth H. Thomas Jr.)

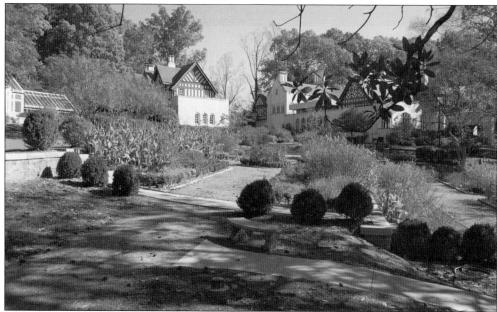

The Callanwolde Castle and Garden was home to Charles Howard Candler, son of Asa Candler and successor to the Coca-Cola Company. The house was built in the 20th century and designed by Henry Hornbostel of New York in the 19th-century Gothic Revivalism style. Callanwolde is currently a fine-arts center overseen by a board of directors, many of them descendants of Candler, in collaboration with Dekalb County. (Courtesy Caskey Cunningham.)

Eight

CEMETERIES AS PARKS

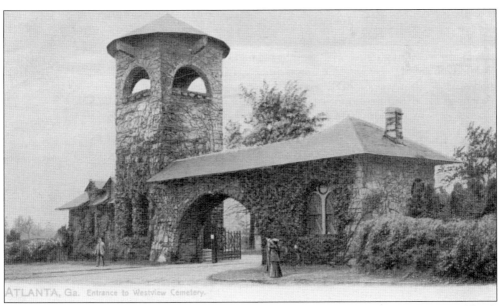

Westview Cemetery is the largest cemetery in the Southeast, containing 582 acres of land. Westview exemplifies the Victorian tradition of cemeteries as picturesque parks. In use since 1884, it contains the remains of many prominent Atlanta figures. It was built because of the rising death toll from the Civil War. The entrance gate is one of the oldest standing structures in Atlanta. E.P. McBurney purchased the cemetery land in August 1884, and the main gate was constructed that same year. (Courtesy Kenneth H. Thomas Jr.)

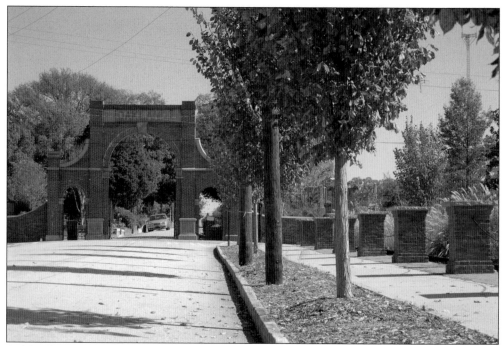

Oakland Cemetery, originally known as the Atlanta Graveyard or City Burial Place, began with six acres in 1850. The cemetery reached its current size in 1867, having been expanded to 48 acres due to the rising death toll from the Civil War. Throughout the 19th century, Atlanta citizens began using the cemetery as grounds for leisure activities such as carriage rides and picnics. Oakland Cemetery also follows the Victorian tradition of cemeteries as picturesque parks. (Both courtesy Caskey Cunningham.)

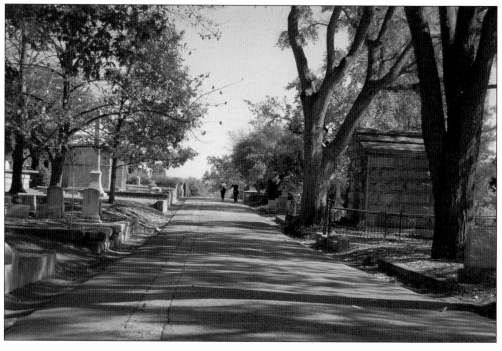

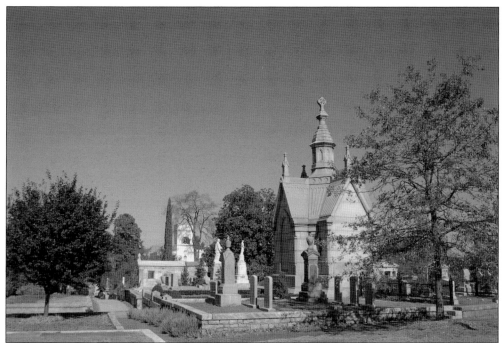

There are 50 miles of brick streets and walkways in the cemetery. The last remaining plots in Oakland were sold in 1884, leading to the development of Westview Cemetery. It began to fall into disrepair in the 20th century, and the Historic Oakland Foundation was founded in 1976 to improve and restore the grounds and monuments. Oakland was listed in the National Register of Historic Places that same year. (Both courtesy Caskey Cunningham.)

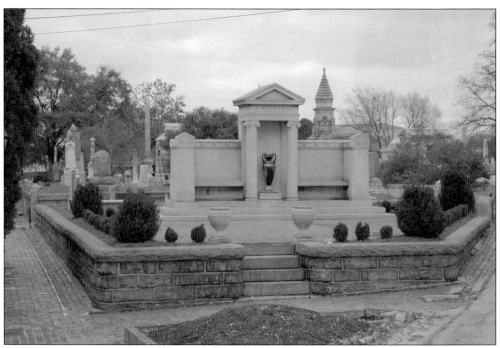

Oakland Cemetery, a necropolis, is laid out in a dense urban pattern. Interesting intersections allow for fanciful tombs such as the classical James English family tomb. (Courtesy Ken Insley.)

The Mims Obelisk is that of Atlanta's sixth mayor, John Mims, who was the patron responsible for gifting the land on which the Georgia State Capitol stands today. (Courtesy Ken Insley.)

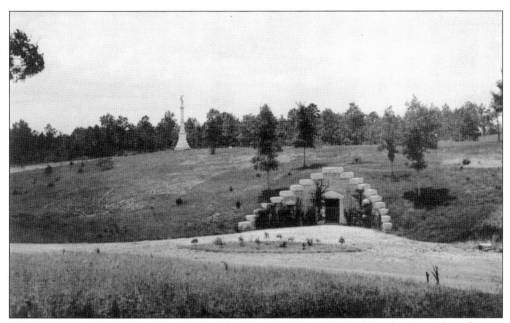

The Westview Cemetery receiving vault had a valuable purpose when the Spanish influenza epidemic of 1918 killed many victims; the dead were stored in caskets in the receiving vault until the epidemic had passed and it was safe to bury them. Atlanta lost 750 citizens to the flu epidemic. The historic vault was sealed permanently in 1945. (Courtesy Caskey Cunningham.)

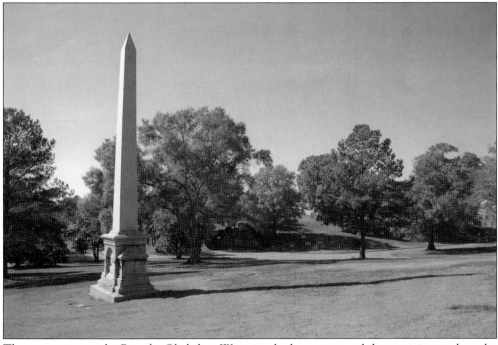

The prospect near the Brumby Obelisk at Westview looks west toward the receiving vault to the left. (Courtesy Caskey Cunningham.)

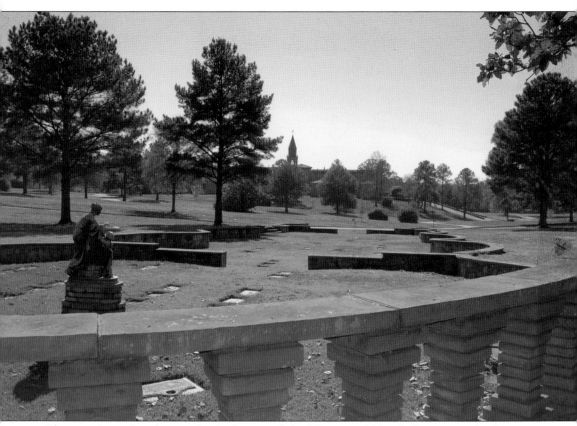

The parterre and sunken garden looks toward the Westview Abbey bell tower in the distance. (Courtesy Caskey Cunningham.)

Nine

FOUNTAINS

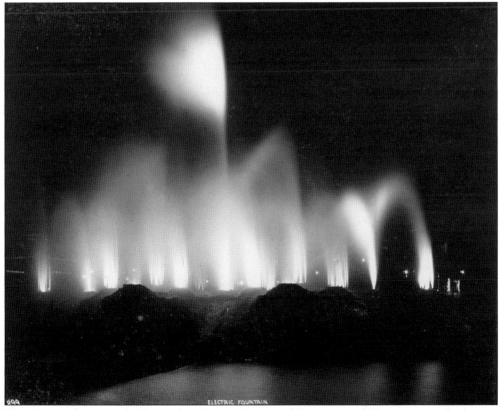

The electric fountain display at the Cotton States and International Exposition took place at nighttime in the fall of 1895. The enormous lighted waterworks was considered a novelty at the time. (Courtesy AHC.)

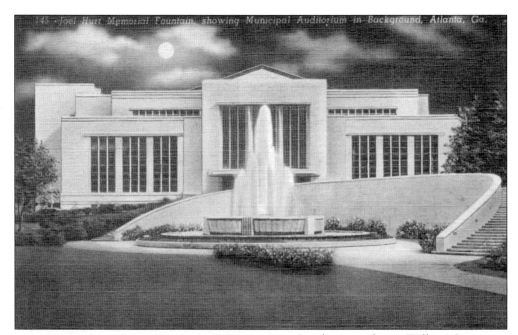

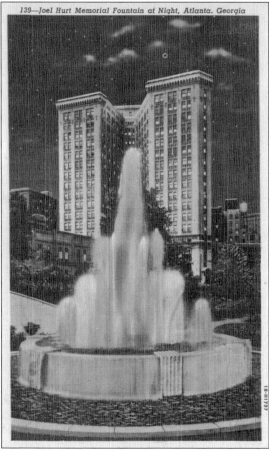

139—Joel Hurt Memorial Fountain at Night, Atlanta, Georgia

Landscape architect William C. Pauley designed Hurt Park and a monumental fountain containing a rainbow of lights, one of the only construction projects during the Great Depression in downtown Atlanta. (Both courtesy J. Cook.)

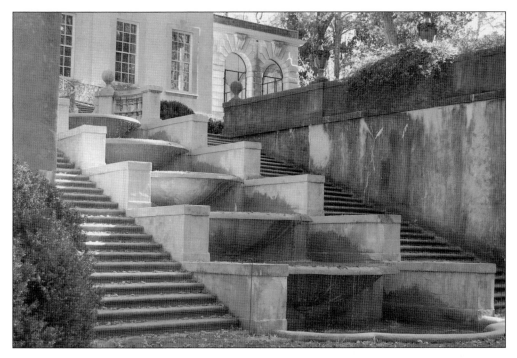

The Swan House was built in 1928 for the Edward H. Inman family. The mansion was designed by architect Philip Trammell Shutze in the English Baroque style. The cascade fountains at the front of the house are modeled after a fountain in the gardens of the Villa Corsini in Rome, Italy. The boxwood garden and fountain are framed by two freestanding double columns that flank a sculpture of an eagle. (Both courtesy Caskey Cunningham.)

The lower basin has two quatrefoil fountains with a single spout. Named for the swan motifs adorning the house interior, the Swan House is now the property of the Atlanta History Center; it is operated as a house museum open to the public. (Courtesy Caskey Cunningham.)

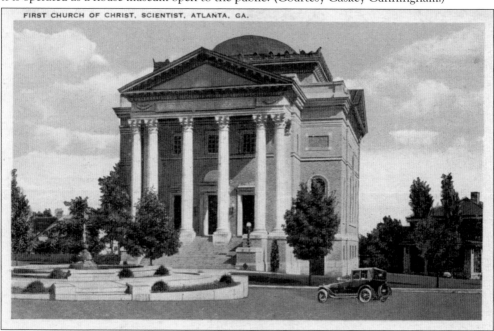

FIRST CHURCH OF CHRIST, SCIENTIST, ATLANTA, GA.

This fountain, located at Peachtree and Fifteenth Streets in Midtown, was donated by the Daughters of the American Revolution. The First Church of Christ Scientist faces the waterworks. Built in the Classical Revival style, architect Arthur Neal Robinson designed the building, and construction was completed in July 1914. Mary Baker Eddy, the founder of Christian Science, healed Sue Harper Mims, wife of Mayor Livingston Mims, and the church was erected as a result. (Courtesy Kenneth H. Thomas Jr.)

The fountains at Underground Atlanta are by the site of the old train depot on Martin Luther King Jr. Drive, near the original Coca-Cola Museum, and the wall cascade is at the Five Points entrance main staircase. The depot was known as the Georgia Freight Railroad Depot. The original Coca-Cola Museum was in operation for 16 years, starting in 1991, until a larger World of Coca-Cola was built at Pemberton Place in May 2007. Underground Atlanta is a popular retail and entertainment center. (Courtesy NMF and World of Coke.)

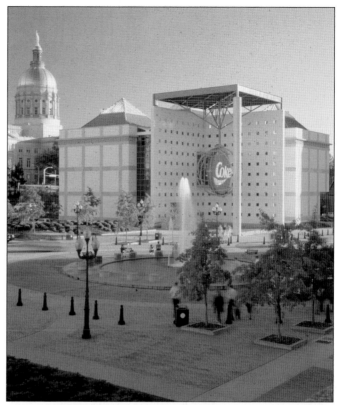

A marble exedra bench surrounds the beautiful Erskine Fountain at historic Grant Park. It was a gift to the park and the city from the Erskine family and surrounded a two-tiered bronze bowl fountain on legs. (Courtesy Kenneth H. Thomas Jr.)

The Atlanta Botanical Garden was incorporated as a nonprofit organization in 1976. The garden has since become an expansive and extremely popular attraction in Atlanta. Its many garden exhibits include the Canopy Walk, Cascade Garden, Edible Garden, Fuqua Conservatory, Outdoor Kitchen, and the Storza Grounds/Woods and elevated walk. The fountain shown here showcases the glass sculpture exhibition called "Chihuly in the Garden." The exhibit took place in 2004 and is typical of the variety of exhibitions that take place there. (Courtesy Ken Insley.)

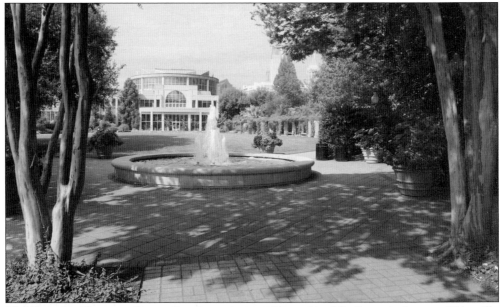

The Dorothy Chapman Fuqua Conservatory was donated by J.B. Fuqua in honor of his wife. Opened in March 1989, it houses plants from tropical and desert environments. The conservatory has five different exhibit areas, including the Main Lobby, a Tropical Rotunda, a Desert House, Special Exhibits, and an Orangerie. (Courtesy Ken Insley.)

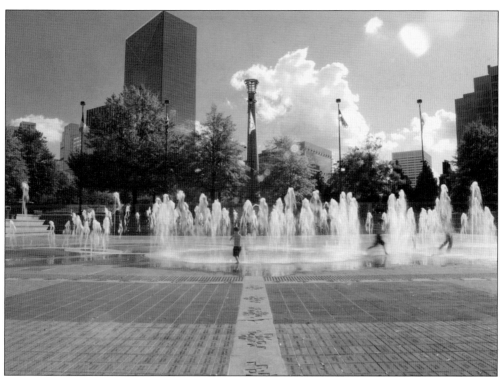

Centennial Olympic Park was developed by Olympics Committee Chairman Billy Payne and introduced in March 1996. The park became a destination for millions of visitors to enjoy the 1996 Centennial Olympic Games. The Olympic Rings Fountain allows visitors to interact with it, which, if careful, can be done without getting wet. (Courtesy Ken Insley.)

One Atlantic Center, or the IBM Tower, is the third tallest skyscraper in Atlanta. The Gothic tower, completed in 1987 at 820 feet tall, was designed by Johnson/Burgee Architects. The cascade fountains can be seen under the trees and are evocative of the Villa d'Este near Rome. (Courtesy Caskey Cunningham.)

This fountain/waterfall at Margaret Mitchell Square was designed by Maya Lin, the notable designer of the Vietnam Memorial in Washington. (Courtesy NMF.)

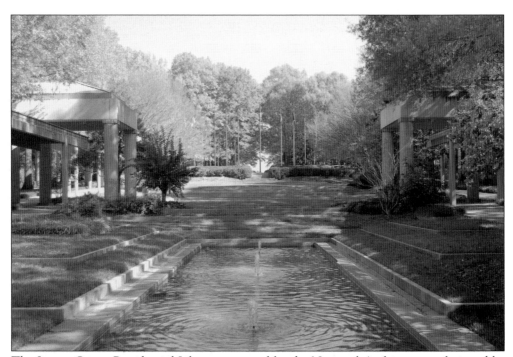

The Jimmy Carter Presidential Library, operated by the National Archives, was designed by Jova/Daniels/Busby Inc. It contains the presidential library donated to the federal government, President Carter's oval office, and more. The Carter Center of Emory University operates from the same complex but is run independently. The library was opened to the public on October 1, 1986. (Courtesy Caskey Cunningham.)

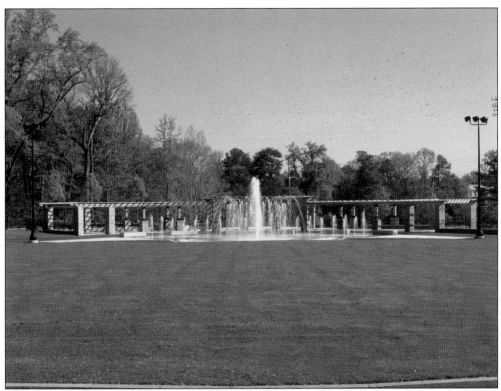

The Legacy Fountain in Piedmont Park is the culmination of a significant park expansion to the north. It is an expansive waterworks, and children are encouraged to play in it. It is approached by a monumental staircase over a great oval lawn, which is also aligned with another staircase to the Storza Woods of the Atlanta Botanical Garden. (Courtesy Piedmont Park Conservancy.)

Woodruff Park is named in honor of Robert W. Woodruff, former CEO of the Coca-Cola Company and one of America's most prominent philanthropists. The park's land was secretly purchased by Woodruff and donated to Atlanta in 1971. The curved-wall cascade fountains directly below the Candler Building and the Central Fountains provide superb sound effects for lunchtime visitors, as the park is completely surrounded by towers. (Courtesy Ken Insley.)

The central fountain has a spout that will rise 20 feet in the air. The historic English-American Building, or Flatiron Building, is in the background. The Atlanta Flatiron Building predates the New York Flatiron Building by a number of years. (Courtesy Ken Insley.)

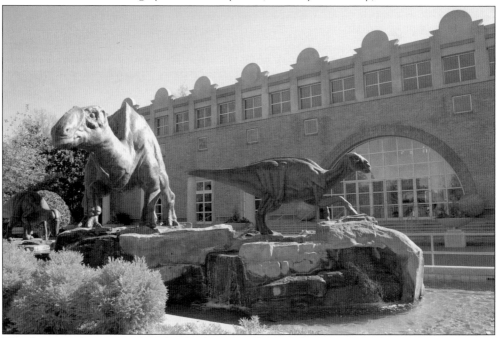

The dinosaur fountain at Fernbank Museum of Natural History, which is beloved by every child in town, can be found in Druid Hills. The view from the museum building beyond the fountain is the great lawn of the museum and the Druid Hills Golf Club grounds. The visual aspect makes the scene appear as if the earth's early inhabitants are in their natural habitat. (Courtesy Caskey Cunningham.)

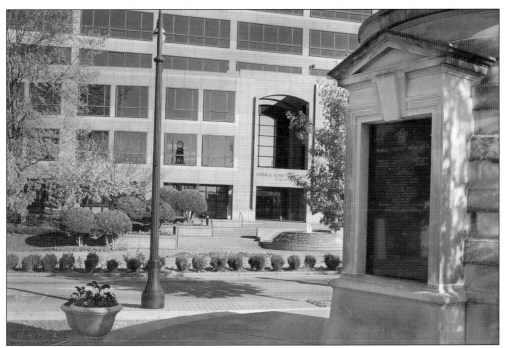

The Federal Home Loan Bank Fountain provides wonderful relief from the heat of the heavily trafficked gateway to the principle cultural district of the city. It is located at Princess Diana Memorial Plaza at Pershing Point. (Courtesy Caskey Cunningham.)

The Westview Abbey Fountain is on an appropriate scale with the Abbey itself. The Spanish Renaissance–style complex is located in the historical West End district of the city. (Courtesy Caskey Cunningham.)

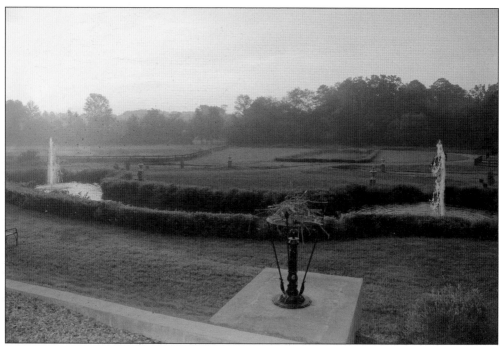

The crescent fountains at Alexandra Park are most beautiful at sunrise, as exhibited here. The sun aligns with the canal and the crescent fountain on June 16 every year. (Courtesy NMF.)

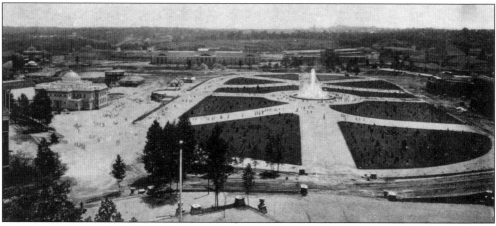

The greatest fountain in the city's history was in the center of the Grand Ellipse of the Cotton States and International Exposition of 1895. It was on the same scale as the Buckingham Fountain in Chicago's Grant Park. Now called the Active Oval, the fountain in its center has been replaced by a pavilion, and today this view looking south is entirely surrounded by skyscrapers. (Courtesy AHC.)

Ten

FUTURE PARKS
AND MONUMENTS

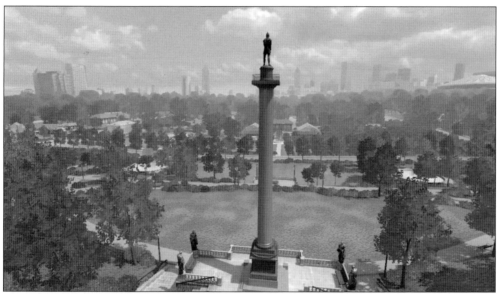

The following three images are computer renderings of Mims Park, named for the original initiative brought forth by Mayor Livingston Mims. Designed in the late 19th century by the Olmsted Brothers, arguably the most notable American landscape firm in American history, the original Mims Park also contained Atlanta's first playground for children. Constructed by order of Mayor Mims, the playground brought together the area's children, regardless of race, in an attempt to forge bonds for the city's future. The Peace Column is topped by Chief Tomochichi, who is considered the cofounder of Georgia with General Oglethorpe. Tomochichi could have chosen to massacre the British colonists, but he opted for peace instead and established Georgia's tradition of peace and a century of harmonious British Colonial–Native American coexistence in Georgia. The top of the column will be accessible by elevator. (Courtesy NMF.)

A school was located at Mims Park, but over a 50-year period it grew to a size that overtook the park. This reconstruction by the National Monuments Foundation has received the acclaim and full support of the mayor of Atlanta and the city council. The historical park will revitalize an important district, not only for the citizens of this city and state, but also for the millions who visit the area. A view on the western axis looks through the greenhouse plaza of the urban farm towards the Peace Column in the distance. The dome of the Peace Pantheon, a memorial to all Georgia sons and daughters who were champions of peace, is to the left on the park's highest point. (Both courtesy NMF.)

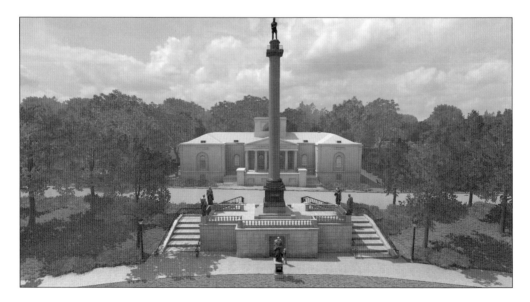

Graffiti, or street art, has grown to become a popular form of art. The Krog Street Tunnel in Cabbagetown is a favorite street for graffiti artists. The street has become the most famous street art space in Atlanta. The BeltLine is also a popular place to display street art, and once it is completed there will most likely be a permanent installment there. (Courtesy Caskey Cunningham.)

DISCOVER THOUSANDS OF LOCAL HISTORY BOOKS FEATURING MILLIONS OF VINTAGE IMAGES

Arcadia Publishing, the leading local history publisher in the United States, is committed to making history accessible and meaningful through publishing books that celebrate and preserve the heritage of America's people and places.

Find more books like this at
www.arcadiapublishing.com

Search for your hometown history, your old stomping grounds, and even your favorite sports team.

Consistent with our mission to preserve history on a local level, this book was printed in South Carolina on American-made paper and manufactured entirely in the United States. Products carrying the accredited Forest Stewardship Council (FSC) label are printed on 100 percent FSC-certified paper.

MADE IN THE USA